The **TIFFEN** Practical Filter Manual

Robb Smith

AMPHOTO
American Photographic Book Publishing Co., Inc.
Garden City, New York

Preface

The purpose of this book is to explain clearly and simply how to use filters to make better pictures. It is a working guide that concentrates on practical applications. It is designed to clear up much of the confusion and misunderstanding that surrounds the subject of filters so that photographers from beginner to advanced can use filters easily and effectively.

All photographs for this book were prepared as sets of two or more, showing the same subject taken both with and without filter so that comparisons can be made. When studied together, the photographs and text provide a complete course in the practical use of filters.

The decision to base this book on Tiffen filters was made in part because the Tiffen Manufacturing Corporation is America's largest manufacturer of filters, and because the numbers that identify Tiffen filters are identical to Kodak Wratten filter numbers. This numbering system is the most widely used in the world today and comes closer than any other to approximating an international standard.

There are also color names for Tiffen filters, and these have been included in parentheses after the filter numbers throughout the book as an aid to learning about filters in terms of their color.

I would like to thank the Tiffen Manufacturing Corporation for its help in preparing this book. In writing the text, I have used a number of registered trademarks that belong to the Tiffen Manufacturing Corporation. Among these are: Tiffen, Photar, FLD, FLB, DM, and Show/Corder.

The practical information about the use and effect of specific filters should be considered only a guide. So many variables enter into the photographic process that it is impossible to set down hard and fast rules about what a filter will do or how it should be used in a particular situation. The only way to be certain is to run tests and examine the results every time a filter is used. If a photograph is considered very important, then tests should be made. For the average run of photographs, most photographers are happy using the general guides and accept the occasional unexpected result as part of the never-ending process of learning about photography.

Robb Smith
New York, 1975

Contents

Preface 3

1 Filter Basics 7

2 Filters for Black-and-White Photography 15

3 Filters for Color Photography 33

4 Special-Purpose and Special-Effect Filters 45

5 Close-up Photography 61

6 Creative Filter Applications 69

7 Practical Guides to Filter Selection 74

8 Technical Problem Solving 84

Glossary 94

Index 95

1

Filter Basics

Most experienced photographers would agree that filters are as essential to good picture taking as ownership of a camera. A photographer may spend hundreds of dollars on fine lenses and other precision equipment, yet be unable to get the results he wants without a filter that costs only a few dollars. In black-and-white photography, it is often a filter that makes the difference between a dull, washed-out photo and one that sparkles with subtle tonal variations or brilliant contrasts. In color work, filters are essential for correct color rendition in a vast number of common photographic situations.

This book is designed to provide all the basic information needed to use filters easily and effectively. The emphasis throughout is on practice rather than theory. The text and illustrations are intended as a guide that serious photographers at all levels of expertise can use in their day-to-day picture taking.

Beginning with basic information, this book is structured to allow even beginners to use filters effectively. Each chapter provides progressively more information; first dealing with filters for black-and-white photography, then filters for color, then the special filters used for both types of photography. Succeeding chapters deal with close-up photography, and filters for

special effects. Chapter 7 is a guide to filter selection. It is filled with suggestions for handling specific subjects and lighting conditions. The final chapter is devoted to advanced technical problems and is intended primarily for experienced photographers.

What a Filter Does

A filter is a precisely engineered optical device that blocks out, or absorbs, light that would normally enter the lens. The effect its action has on the final picture depends on what portion of the light is absorbed, the color quality of the light on the original scene, the colors in the subject, and the type of film in the camera. Although this may seem complicated at first, it is actually fairly simple.

To understand the action of a filter, think of white light as being composed of three basic, or primary, colors—red, green, and blue. You can think of all colors as being composed of varying amounts of the three primaries. When you place a colored filter over the lens, you change the proportions of blue, green, and red light that strike the film when you take the picture. When using color film, this results in a change in the overall color of the image. In black-and-white photography, filters change the relative brightness of objects so

that anything with a color similar to the filter used will appear lighter, and colors that are blocked by the filter will appear darker in the final print. This is because in the negative/positive process, the colors blocked by the filter produce light areas on the negative and this in turn produces dark areas on the final print.

For example, the following happens when you use a red filter. The red absorbs almost all the blue and green light, and some red as well; hence, the image formed by the lens is composed almost entirely of red light. If you have color film in your camera the final picture will be a monochromatic red. With black-and-white film, the result is a picture in which the normal tonal values are altered dramatically: blue skies are dark grey, clouds appear stark white; and red lips or bricks appear chalky. Red objects and very light colored objects, with a high proportion of red, create the greatest density on the negative and therefore the lightest areas on the print. Light from a green bench or blue eyes is absorbed by the red filter, so these subjects appear light in the negative and very dark in the final print.

When you use a red filter, more than 80 percent of the light that would normally contribute to exposure may be absorbed by it. For proper exposure, you must either use a slower shutter speed or open up the lens $2\frac{1}{2}$-3 f/stops to compensate for the

1-1a. No filter

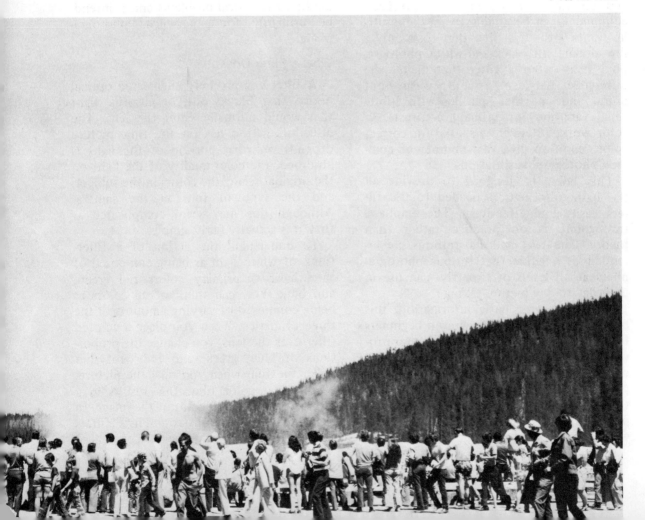

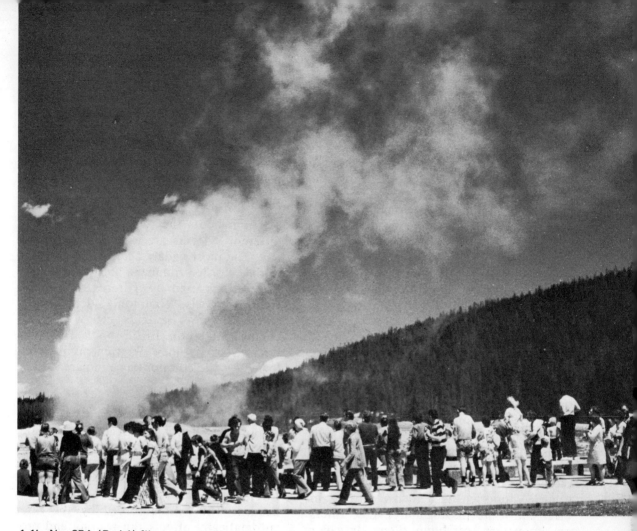

1-1b. No. 25A (Red 1) filter.

1-1a & b. Old Faithful in Yellowstone National Park is a disappointing subject when photographed without a filter. The erupting water and steam is lost against the brilliance of the sky and the picture leaves the viewer wondering what everyone is looking at. When photographed through a No. 25A (Red 1) filter, the sky darkens dramatically, and the eruption is captured on film. Both photos were taken with a camera that automatically set the exposure. Camera: GAF Memo 35EE. Film: Ilford FP4.

loss of light. If you use an automatic camera that takes an exposure reading through the filter, then this compensation is made automatically. If you do not take your exposure reading through the filter, then you must calculate the exposure compensation required by using a filter factor—discussed later in this chapter.

Filter Effects

In some cases, the effect a filter will have on the final picture can be estimated by glancing at the subject through the filter. This is often true when you use deep colored filters, such as the No. 25 (Red 1). In most cases however, advance knowledge of the effect a filter will have can only be

gained through experience or by reading a book such as this. The reason is that film does not respond to light in the same way as your eye.

When you look at a scene, you use a complex system of sensory and mental faculties; you can unthinkingly compensate for changes in the intensity of color or light in fractions of a second, and prolonged looking at almost any scene makes it appear normal. Film does not share human adaptability. It is designed to respond approximately the way the eye does in one situation only. For daylight color films and most general-purpose black-and-white films, this one situation is for subjects illuminated at midday by a mixture of sunlight and blue skylight.

When film is correctly exposed in the one situation for which it is designed, it gives you a reasonably accurate rendition of the scene. Under other lighting conditions, the image reproduced will not look like what you saw when you took the picture. To get correct color or tonal values, you often need to use a filter. In black-and-white photography, these filters are known as *correction filters.* In color work, minor corrections are achieved by using *light-balancing* or *Decamired* filters. When a major color correction is called for, as when using daylight film indoors with normal household lighting, *conversion filters* are required.

Filters may also be used to exaggerate certain conditions. In black-and-white photography this is done with *contrast filters,* which can be used to darken a sky, lighten a particular color, or even eliminate a stain on an old photo that you are copying. In color work, tonal exaggeration is achieved by using an appropriately colored filter, or one of the special-purpose or special-effect filters.

The *special-purpose filters* can be used with both black-and-white and color films. This group includes polarizing filters, which reduce the effect of glare and help darken blue skies, and neutral density filters, which are used to control exposure.

Special-effect filters are used to modify the image in unconventional ways. Tiffen manufactures star, fog, diffusion, and low-contrast effect filters for this purpose.

Filter Nomenclature

Throughout the world a number of different systems are used to identify filters. The most widely accepted is based on Kodak Wratten numbers, and these are the designations used by Tiffen. In the past, filters were also commonly identified by color or name, such as yellow 1, deep yellow, and so on. In this book, filters are referred to by their Wratten number followed by the color or name in parentheses.

Exposure with Filters

As mentioned, because filters reduce the amount of light that reaches the film, exposure compensation must be made. With through-the-lens metering cameras, the exposure reading is made through the filter, and in most cases no adjustment is needed. The light absorbed by the filter automatically affects the reading and produces a good exposure with average scenes. In special situations, slight adjustments may be required—these are discussed in sections covering individual filters.

1-2a, b, & c. The use of deep color filters with black-and-white film dramatically alters tonal values of colored objects. In this series of photos, bright red pens are lying on top of a deep green scouring pad. The grey border on the left and bottom is a neutral grey card which reflects all colors and therefore is unaffected by the filters.

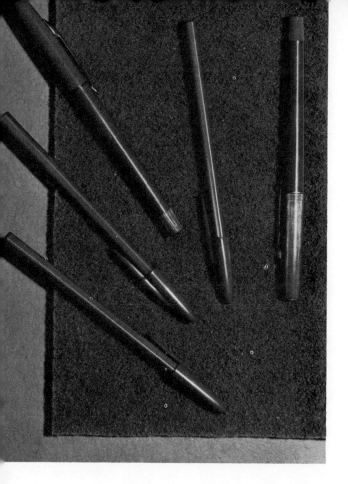

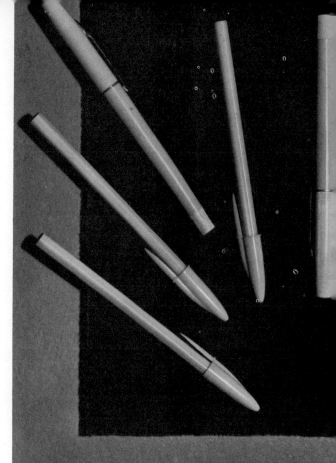

1-2a. No filter.

1-2b. No. 25A (Red 1) filter darkens
the green pad and lightens the red pens
(above right).

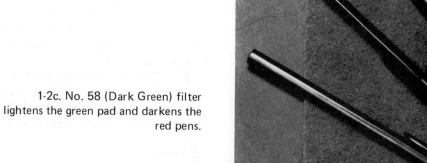

1-2c. No. 58 (Dark Green) filter
lightens the green pad and darkens the
red pens.

When you do not make exposure readings through the filter, you must then compensate for the light absorbed by the filter. The amount by which exposure should be increased is known as the *filter factor*. This is written 1.5X, 2X, 3X, and so on, depending on the filter. To use a filter factor, divide the ASA rating of the film by the factor and use the result as the ASA at which the film should be exposed with the filter in place. For example, a No. 9 (Yellow 3) filter has a factor of 2X in daylight; this would effectively reduce the rating of an ASA 400 black-and-white film to ASA 200.

Filter factors can also be thought of in terms of *f*/stops and shutter speeds. With a filter in place, reducing light to the film, exposure compensation can be made by using a wider *f*/stop or a slower shutter speed. For example, using an ASA 64 film outdoors in sunlight, the usual exposure would be 1/60 sec. at *f*/16. Using a filter with a factor of 2X you would have to double your exposure either by lowering the shutter speed to 1/30 sec., or opening the lens diaphragm to *f*/11.

A common practice among experienced photographers is to equate filter factors with *f*/stops and then think of each filter as being a one-stop, two-stop, or three-stop filter, and so on. Thus, a one-stop filter would require an increase in exposure of one *f*/stop. A No. 11 (Green 1) filter has a factor of 4X, which makes it a "two-stop" filter. In this book, exposure compensations are given as filter exposure factors and *f*/stops. The accompanying table shows how filter factors equate to *f*/stops.

Filter factors, or their equivalent in *f*/stops, should be considered guides to exposure. The actual exposure required may vary considerably, depending on the effect desired, lighting conditions, subject color, film used, exposure meter used, and individual processing procedures. Readings taken through the filter should also be considered only as guides. Both filter fac-

EXPOSURE INCREASE IN *f*/STOPS REQUIRED FOR FILTER FACTORS

Filter Factor	Exposure Increase in *f*/stops*
1X	no increase
1.5X	$^1/_2$
2X	1
3X	1-$^1/_2$
4X	2
5X–6X	2-$^1/_2$
7X–9X	3
10X–13X	3-$^1/_2$
14X–18X	4
20X–27X	4-$^1/_2$
30X–35X	5

*Exposure increase required has been rounded off to the nearest $^1/_2$ *f*/stop. For critical work, $^1/_3$ *f*/stop may be used, in which case 1.5X = $^1/_3$ *f*/stop; 3X = 1-$^2/_3$ *f*-stops; 5X = 2-$^1/_3$ *f*-stops; and so on.

tors and through-the-filter readings are adequate for most situations. You can use them with reasonable confidence, but you should feel free to vary them at will. The truth is that outside of laboratory conditions, practical photographic experience is the one sure way to consistently good exposures.

Filter Quality

Despite its simple appearance and relative low cost, a filter is a sophisticated optical component that must be of the highest quality if it is to be used with confidence. The difference among filters is more than just price. A poor filter can introduce optical aberrations and color variations into your camera system, which can ruin pictures.

The Tiffen Manufacturing Corporation has long recognized that the optical qualities of its filters must match that of the finest contemporary lenses and that they

FILTER CONVERSION CHART

Filter Factor	If normal f/stop without filter is:												
	1.4	1.8	2.0	2.5	2.8	3.5	4.5	5.6	6.3	8	11	16	22
	Then here's f/stop with filter. No calculation necessary!												
1.5	1.1	1.3	1.6	2.0	2.3	2.9	3.7	4.6	5.1	6.6	9.2	12.5	18
2		1.2	1.4	1.8	2.5	2.8	3.5	4.5	5.6	6.3	8.0	11.3	16
2.5			1.2	1.6	2.3	2.5	3.2	3.6	4.0	5.2	7.1	10.1	14
3				1.4	1.6	2.0	3.0	3.3	3.6	4.6	6.6	9.2	13.1
4				1.2	1.4	1.7	2.5	2.8	3.2	4.0	5.6	8.0	11.3
5					1.3	1.6	2.2	2.5	2.9	3.6	5.0	7.2	10.1
6						1.4	2.0	2.3	2.6	3.3	4.5	6.3	9.2
7						1.3	1.8	2.1	2.4	3.0	4.2	6.1	8.5
8							1.6	2.0	2.2	2.8	4.0	5.6	8.0
10							1.4	1.8	2.0	2.5	3.5	5.0	7.1

must give consistent performance under a wide variety of environmental conditions. As a result, Tiffen filters have become the first choice of professional still and motion-picture photographers throughout the world.

The National Aeronautics and Space Administration (NASA) selected stock Tiffen filters for the Apollo moon flights because of their exceptional ability to withstand extreme environmental conditions with no change in quality. Stock filters are also being used by the NASA Earth Resources program. They are used, too, by all major motion-picture studios and for all Panavision films.

Every Tiffen filter is checked and re-checked throughout every step of the production process, and all manufacturing is done under one roof to maintain optimum quality control. Each Tiffen filter consists of two pieces of optical glass laminated together by heat and pressure. The dyes used are carefully selected for stability in sunlight, heat, and cold. They have been subjected to fade-o-meter tests to ensure maximum resistance to discoloration and fading. The result is a filter that combines optimum quality with durability.

These filters can be immersed in water for prolonged periods without any deterioration of color or bonding material. They are resistant to fungus and can be subjected to temperatures up to 200° F. without change in color, bonding material, or durability. At the end of the production process, each filter is individually checked by experienced inspectors, and hand assembled in mounts manufactured in the Tiffen plant.

Filter Sizes

From lens to lens the correct filter size and method for mounting varies. If you are unsure about the filter size and mount required for your camera's lens, consult your photo dealer or write directly to Tiffen giving the make and model number of your camera. If you are using interchangeable lenses, describe the lens with the information inscribed on the front of the lens (f/number, focal length, and name of lens).

Tiffen filters are available in three differ-

ent forms—series-size, screw-in, and square. The *series-size* filters are designed for use with an adapter ring. In this system, the filter glass is permanently mounted in a black, Anolite-finished ring, engraved with the size and color for easy identification. This filter is slipped into a Tiffen adapter ring that mounts on the front of the lens and is held firmly in place by a retaining ring or lens hood. Screw-in, bayonet, slip-on, and set-screw adapter rings are available. No matter what camera or lens you own, there is probably a Tiffen adapter made for it.

Photographers who own more than one camera or lens often prefer series-size filters, because one set of filters can be used with a number of different adapters to fit lenses requiring different filter mount diameters or mounting systems. The only requirement is that you choose a size that is large enough to cover the full surface of all the lenses without causing vignetting—a darkening at the corners of the image.

Tiffen also manufactures *screw-in* filters which are threaded to fit directly into the camera lens. They are made in standard diameters for all popular lenses using this system. The front of the filter is also threaded to allow you to add a lens hood, another filter, or other accessory if desired.

Square filters, in 3" X 3" and 4" X 4" sizes, are designed for use with a Tiffen Professional filter holder, which attaches to a standard Tiffen adapter ring. These filters are used in the main by professional photographers working with technical (view) cameras or motion-picture cameras. Tiffen filters are also available in other sizes and shapes up to 12" X 12" on special order.

For additional information on adapter rings and methods for making a single set of filters serve for several cameras or lenses, see the section on "Lens Accessories" in Chapter 8.

Handling Filters

If you treat a Tiffen filter as you would a good lens, it will give years of service.

Avoid touching the filter glass with your fingers. Oil and acids on the skin can mar the surface of a filter. If you get a fingerprint on the glass, clean it immediately. A clean, camel's hair brush can be used to remove dust from filters. Cans of pressurized inert gas, available from photo dealers, are also useful for removing dust and grit.

You can generally remove grime that sticks to the filter by breathing on the glass to moisten it and gently wiping it with a piece of crumpled lens tissue or clean, lint-free cloth. Alternatively, use a drop of lens cleaning fluid on the tissue and wipe the glass gently. Do not apply pressure, which could cause particles to dig into the surface; use the lens cleaning tissue as though it were a brush. Do not use tissues sold for cleaning eye glasses, and never use ordinary paper, which can scratch the glass.

To protect your filters while keeping them readily accessible, you should consider a filter safe. This is a zippered pouch designed to hold four screw-in or series-size filters in individual, see-through pockets.

2

Filters for Black-and-White Photography

Today's general-purpose black-and-white films are panchromatic, meaning that they are sensitive to all visible colors of light; however, the degree of sensitivity to red, blue, and green light varies, depending on the film. Films such as Kodak Panatomic-X, Kodak Plus-X Pan, GAF 125, Ilford FP-4, Kodak Tri-X Pan, and so on, respond to brightness in approximately the way that the human eye responds, although they are a bit overly sensitive to blue and invisible ultraviolet rays.

Special-purpose films, on the other hand, vary considerably in their response to light. Some are panchromatic but have extended red sensitivity to make them suitable for extreme, low-level-light photography. Orthochromatic films used in copying and in the graphic arts are sensitive to blue and green, but not to red. And the "litho" films used in the printing industry are sensitive only to blue. The effect that filters have with these special-purpose films depends on the properties of the particular film's emulsion.

This chapter examines the use of filters with general-purpose black-and-white films. Filter factors with orthochromatic films are given in Chapter 7; filter use with infrared sensitive films is covered in Chapter 6.

CORRECTION FILTERS

Even today's general-purpose panchromatic films will not produce the relative brightness of tones in a scene in exactly the same proportions as they were revealed to the eye at the time the picture was taken. Since the difference in most instances is slight, this ordinarily presents few problems. However, blues, particularly blue skies, tend to be reproduced too light, and greens and reds may be too dark. Some photographers are content to ignore these minor image defects, but correction with appropriate filters is standard practice among professionals and serious amateurs.

The type of correction filter required depends on the lighting situation, the film used, and the type of photograph being made. The standard filter for full correction in daylight with most panchromatic films is the No. 8 (Yellow 2). This filter darkens blue skies, which in turn helps bring out clouds. It also lightens reds and greens. This effect occurs because yellow is actually a composite color consisting of green and red light; the No. 8 (Yellow 2) passes red and green freely, but holds back some of the blue light, which results in more natural grey tones in the final print.

TIFFEN FILTERS
FOR BLACK-AND-WHITE PANCHROMATIC FILM

Filter No.*		Suggested Uses	f/Stop Increase	
			Day-light	Tung-sten
3	(Aero 1)	Aerial photography, haze penetration	$^2/_3$	—
3N5	(Yellow)	Combines No. 3 with 0.5 neutral density	2	$1\text{-}^2/_3$
6	(Yellow 1)	For all black-and-white films, absorbs excess blue, outdoors, thereby darkening sky slightly, emphasizing the clouds.	$^2/_3$	$^2/_3$
8	(Yellow 2)	For all black-and-white films, most accurate tonal correction outdoors with panchromatic films. Produces greater contrast in clouds against blue skies, and lightens foliage.	1	$^2/_3$
8N5	(Yellow)	Combines No. 8 with 0.5 neutral density, for control of high speed films with same application of No. 8 (Yellow 2) filter	$2\text{-}^1/_3$	$2\text{-}^1/_3$
9	(Yellow 3)	Deep Yellow for stronger cloud contrast	1	$^2/_3$
11	(Green 1)	Ideal outdoor filter where more pleasing flesh tones are desired in portraits against the sky than can be obtained with yellow filter. Also renders beautiful black-and-white photos of landscapes, flowers, blossoms, and natural sky appearance	2	$1\text{-}^2/_3$
12	(Yellow)	"Minus blue" cuts haze in aerial work, excess blue of full moon in astrophotography. Recommended as basic filter for use with Kodak Aero Ektachrome Infrared.	1	$^2/_3$
13	(Green 2)	For male portraits in tungsten light, renders flesh tones deep, swarthy. Lightens foliage, with pan film only.	$2\text{-}^1/_3$	2
15	(Deep Yellow)	For all black-and-white films. Renders dramatic dark skies, marine scenes; aerial photography. Contrast in copying	$1\text{-}^2/_3$	1
16	(Orange)	Deeper than No. 15. With pan film only	$1\text{-}^2/_3$	$1\text{-}^2/_3$
21	(Orange)	Absorbs blues and blue-greens. Renders blue tones darker such as marine scenes. With pan film only	$2\text{-}^1/_3$	2
23A	(Light Red)	Contrast effects, darkens sky and water, architectural photography. Not recommended for flesh tones. With pan film only	$2\text{-}^2/_3$	$1\text{-}^2/_3$
25A	(Red 1)	Used to create dramatic sky effects, simulated "moonlight" scenes in mid-day (by slight underexposure). Excellent copying filter for blueprints. Use with infrared film for extreme contrast in sky, turns foliage white, cuts through fog, haze and mist. Used in scientific photography	3	$2\text{-}^2/_3$
29	(Dark Red)	For strong contrasts; copying blueprints	$4\text{-}^1/_3$	2
47	(Dark Blue)	Accentuates haze and fog. Used for dye transfer and contrast effects	$2\text{-}^1/_3$	3
47B	(Dark Blue)	Lightens same color for detail	3	4
56	(Light Green)	Darkens sky, good flesh tones. With pan film only	$2\text{-}^2/_3$	$2\text{-}^2/_3$
58	(Dark Green)	Contrast effects in Microscopy, produces very light foliage	3	3
61	(Dark Green)	Extreme lightening of foliage	$3\text{-}^1/_3$	$3\text{-}^1/_3$

*Tiffen filter numbers are standard Wratten filter numbers.

When used as a daylight correction filter, the No. 8 has a factor of 2X (1 f/stop). A variant of this filter is the 8N5, which combines a .5 neutral density filter with the No. 8. This results in an exposure factor of 5.1 ($2\frac{1}{2}$ f/stops), which is useful when larger apertures are required with high-speed films.

Occasionally, photographers will need all the speed they can get in order to shoot sports or other fast-moving subjects. In this case the No. 6 (Yellow 1) can be used for correction. This filter provides partial correction in daylight with a factor of 1.5X (1/2 f/stop). If you need a stronger effect, or more film speed, then you can ignore the exposure compensation. The slight underexposure increases filter effect, but usually has no adverse effect on the overall image quality. The No. 6 may be preferred for minimal sky darkening in the mountains, where the sky normally photographs somewhat darker than at lower altitudes.

In photoflood or high-efficiency lighting, such as the quartz-halogen lights used in photographic studios, a No. 11 (Green 1) is generally recommended for correct grey-tone rendering of colored objects and portraits of women. This is also an ideal outdoor filter when pleasing flesh tones are desired in portraits against the sky. It produces appropriate sky darkening, helps bring out subtle shades of green in foliage, and gives lips and skin their correct tone values. The No. 11 is not used outdoors more frequently because it has an exposure factor of 4X (2 f/stops), which many photographers find inconvenient.

Portraits of males in tungsten light are sometimes taken through a No. 13 (Green 2), which yields deep, swarthy flesh tones. This filter is also used to lighten foliage in landscape photography and to bring out detail in green plants photographed against the dark brown backgrounds of tree trunks or fallen leaves. In medical photography, this filter helps make red or orange skin lesions, bruises, and other tissue visible.

An additional use of the No. 13 (Green 2) is in darkening red flowers while lightening green foliage. In many instances red flowers against green leaves produce similar grey values when no filter is used. The No. 13 darkens the red blossoms and separates them from surrounding foliage. It has a similar effect in the desert, where you can use it to separate the grey tones of the predominant pale greens and tans that tend to blend together without filtration.

Haze and UV Filters

Ultraviolet (UV) absorbing filters are normally required for black-and-white photography only when you are photographing in clear weather in mountains above 3000 feet, in snow, and at the seashore where the ultraviolet absorbing effect of dust is reduced. Although invisible, UV radiation can affect film. Since these rays do not come to a sharp focus in the same plane as other rays of the visible spectrum, they can form a secondary, or "ghost," image that causes the primary image to appear slightly unsharp. Any UV, haze, color correction, or contrast filter can be used to absorb ultraviolet radiation.

2-1a & b. In tungsten light, a No. 11 (Green 1) corrects for the reddish quality of the light. On the following pages the model is wearing red stockings and a red sweater. In the unfiltered shot, the green plants are too dark, whereas legs, lips and shirt are too light. In the filtered version, all tonal relationships are correct. Because the photographer had to open up two f/stops to compensate for light absorbed by the filter, depth of field is decreased and the plants appear unsharp in the filtered shot. Camera: Nikon FTN with 85mm lens. Film: Kodak Plus-X. Photos by Kathleen Benveniste.

2-1a. No filter.

2-1b. No. 11 (Green 1) filter.

Where minimal correction is desired, a Haze 1 or Haze 2A can be used. The Skylight 1A, normally used in color photography, may also be employed. Mountain climbers and marine photographers often find these filters useful because they reduce the effects of scattered blue and ultraviolet light without excessive darkening of blue sky or water. The No. 3 (Aero 1) has similar applications, although it is used principally for haze penetration in aerial photography.

Some photographers will keep a UV, skylight, or haze filter on their lens at all times. The most common ones have no practical effect on exposure and they protect expensive lens surfaces against such hazards as salt spray, caustic fumes, and sand. The Clear filter, made of optical glass, provides similar protection with no color shift.

Use of a clear filter to protect the lens should be done only when absolutely necessary, because if the filter surface becomes scratched or dirty, image quality will be impaired. It is generally used for protection only when you are photographing at the seashore, from the deck of a boat, or in other situations where the lens might be damaged. In other situations, treat it as a transparent lens cap—to be removed when actually shooting.

CONTRAST FILTERS

Contrast filters are used to emphasize differences among selected tones in the finished print. For example, if your subject is a deep yellow car against a background of blue sky, a normal, unfiltered rendition would show an almost white sky and a medium or dark grey car. Photographing through a No. 15 (Deep Yellow) filter would reverse these relationships so that the sky would be dark and the car light.

This tone-alteration effect is most useful when a subject is of a different color but of approximately the same brightness as its background. Thus, a normal rendition of a red apple hanging among green leaves would show very little difference between apple and leaves. By photographing through a No. 13 (Green 2) or No. 61 (Dark Green) you could darken the apple and lighten the foliage. Photographing through a No. 25A (Red 1) would produce a light apple against a dark background.

Other common uses of contrast filters are to bring out clouds in a blue sky, create dramatic effects, improve detail rendition, and penetrate haze by absorbing scattered blue light.

Using Contrast Filters

The basic rule of thumb for filter selection is that a filter lightens its own color in the scene. This happens because a filter freely passes light of its own color while absorbing other colors, which therefore appear darker in the final print. The following is a guide to the lightening and darkening action of the most commonly used contrast filters.

COLOR OF FILTER	EFFECT IN FINAL PRINT
Yellow	Lightens yellow; some lightening of red and green; darkens blue; helps penetrate haze
Orange	Lightens red and orange; excellent haze penetration; darkens blue
Red	Lightens red; darkens blue and green; excellent haze penetration
Green	Lightens green; darkens red and blue
Blue	Lightens blue; accentuates haze; darkens yellow, green, and red

2-2a. No filter. For portraits of women, this rendition may be preferred over the corrected version.

2-2a, b, c & d. In this series of photographs, the model wears a multicolored dress and stands in front of a blue background. Tonal values in the dress pattern change and the background darkens as progressively stronger filters are used. Lips and skin tones vary, depending on the filter used. Camera: Nikon FTN with 85mm lens. Film: Kodak Plus-X. Photos by Kathleen Benveniste.

2-2b. No. 11 (Green 1) filter. This is the correction filter for the quartz lighting used for this series.

2-2c. No. 15 (Deep Yellow) filter. This darkens the background, but lightens lips and flesh tones.

2-2d. No. 25A (Red 1) filter. This provides strong darkening of the background and dramatic alterations in the pattern of the dress. Lips and skin appear chalky.

Overexposure tends to reduce the effect of a filter; slight underexposure increases filter effect. This occurs because the most useful filters do not totally block the colors they absorb, or darken. There is a certain amount of "leakage," which is precisely calibrated for each filter so that a variety of pictorial effects may be achieved, depending on the filter chosen. These effects are plotted for technical purposes on spectral transmission graphs. For general photography, however, most photographers prefer to be guided by experience and a few rules of thumb.

In general, the filter numbers can be used as a rough guide to the progression of pictorial effects, although the No. 56 (Light Green) is an exception. The series begins with the partial correction achieved with the No. 3 and No. 6 filters, progresses through full correction with the No. 8 and No. 11 to overcorrection and contrast effects as the series works through the Deep Yellows, Oranges, and Reds, and finally arrives at the dark color filters.

Pale and Medium Yellow Filters

The yellow filter was the first to be widely used in photography and is still the most popular, although today many photographers prefer a yellow-green or orange as their standard, or "all around," filter. Yellow filters are primarily used to darken blue skies in order to bring out clouds or provide a more pleasing background tone for figure studies. They are also useful for photographing snow scenes in sunlight, because they absorb the blue light reflected by shadows on snow, which causes them to record too light in unfiltered shots.

Yellow filters lighten blond hair and fair complexions, darken blue eyes, and help subdue freckles. They can also be used to bring out the detail in wet bark, to accentuate tonal variations in early fall foliage, or to improve the rendition of grain in blond or yellowish wood.

The usual first choice for a yellow filter is the No. 8 (Yellow 2), because it is a correction filter, but the stronger effects produced by the No. 9 (Yellow 3) and No. 15 (Deep Yellow) may be preferred when dramatically dark skies or good contrast in marine scenes is desired. A No. 8 is the standard outdoor correction filter for orthochromatic films, although today it is unlikely that you would be using ortho film in a way that would demand such correction.

Deep Yellow and Orange Filters

The effect of these filters on blue skies (a convenient way of sorting out the effect of contrast filters on panchromatic film) lies between that of the No. 9 (Yellow 3) and No. 25A (Red 1). This group includes the No. 15 (Deep Yellow), No. 16 (Orange) and No. 21 (Orange). They darken skies more than the medium yellow filters, help bring out the texture of sand, snow, and rock by holding back some of the blue in the shadows, and render yellow and red objects somewhat lighter than they are perceived by the eye. They are good haze penetrating filters too. If they are used in taking pictures containing people though, faces tend to get a bit chalky and lips are sometimes rendered unacceptably light.

The No. 15 (Deep Yellow) yields dramatic, dark skies and adds sparkle to marine scenes because whitecaps and foam appear light in contrast to the water. It is a good haze filter for aerial photography.

Orange filters lighten subjects that range from yellow to red and darken those that range from violet to green.

Grass and foliage though, which reflect a great deal of infrared and deep red light, may come out lighter than desired when photographed with the No. 21 (Orange).

Medium yellow and orange filters are also used for positive control of aerial perspective, which is the tendency for distant subjects to be rendered as light greys rather than with the full contrast range closer subjects exhibit. This is the result of particles

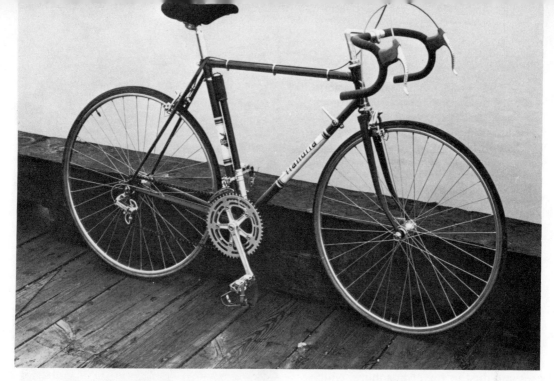

2-3a. No filter.

2-3a & b. Without filter, panchromatic film renders this red bicycle
unnaturally dark. Rephotographing the subject through a No. 15 (Deep
Yellow) filter produced tones that the photographer found more suitable.
Camera: GAF L-ES with 55mm lens. Film: GAF 125. Photo by Ben Zale.

2-3b. No. 15 (Deep Yellow) filter.

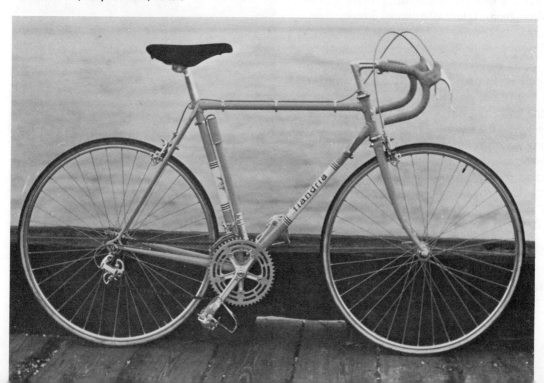

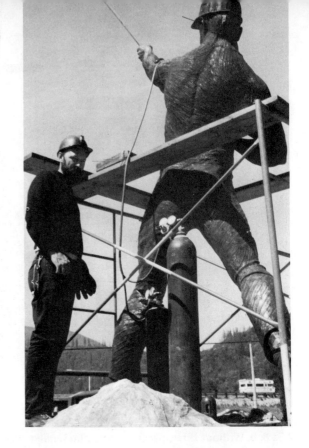

2-4a & b. The Sunshine Miners' Memorial Monument under construction by sculptor and miner Ken Lonn. The dramatic sky darkening is achieved with a No. 15 (Deep Yellow) filter. At high altitudes, stronger filtration is seldom required for this effect. Under the hazy conditions common in cities and coastal regions, a No. 25A (Red 1) might be required to achieve a similar result. Camera: Minolta Hi-Matic F. Film: Ilford FP4.

of water and dust in the atmosphere, which scatter the short blue and violet wavelengths of light. The resulting hazy effect lends mood to scenic photographs, but excessive haze is disturbing. And the effect may yield unacceptable results when you use a long telephoto lens simply because there is more atmosphere between you and your subject. Many photographers use a deep yellow or an orange filter as a matter of course when photographing scenic vistas or when using telephoto lenses longer than 200mm.

If you handhold a telephoto lens, then you generally need all the speed the film can deliver in order to get the high shutter speed required to eliminate camera shake. In this case, the haze penetration provided by the No. 6 (Yellow 1) or No. 3 (Aero 1) filters, which require no exposure compensation, may be sufficient. This is a compromise because you sacrifice some of the clarity that the deep yellow or orange filters provide in favor of maximum film speed.

Red Filters

Dramatic effects in black-and-white photography can be obtained with dark filters that hold back all but the red band of

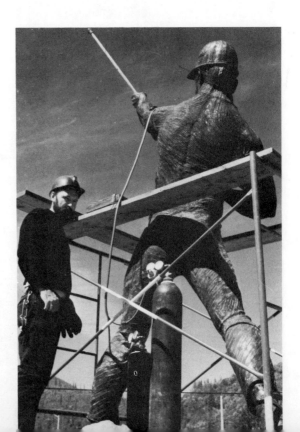

2-5a. No filter.

2-5a & b. Photographs made from airplanes flying at high altitudes are normally unsuccessful without filtration due to haze and scattered ultra-violet radiation. A No. 15 (Deep Yellow) filter provides haze penetration roughly equivalent to that of the human eye. Camera: GAF L-17 with 55mm lens. Film: GAF 125.

2-5b. No. 15 (Deep Yellow) filter.

2-6a. No. 47B (Dark Blue) filter. The blue background is rendered as white whereas stockings, blouse, lips, and plants are dark.

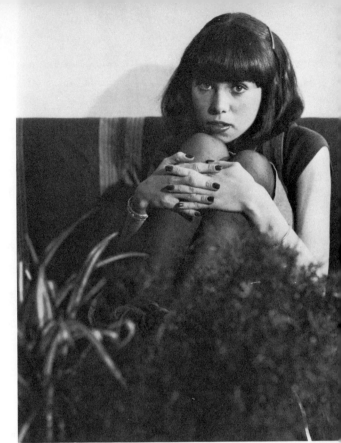

2-6a, b & c. In the photographs on this page the model is wearing red stockings and a red blouse and the background is sky blue. Camera: Nikon FTN with 85mm lens. Film: Kodak Plus-X. Photos by Kathleen Benveniste.

2-6c. No. 25A (Red 1) filter. (Below right) Lips, stockings, and blouse appear light; background and foliage are dark.

2-6b. No filter.

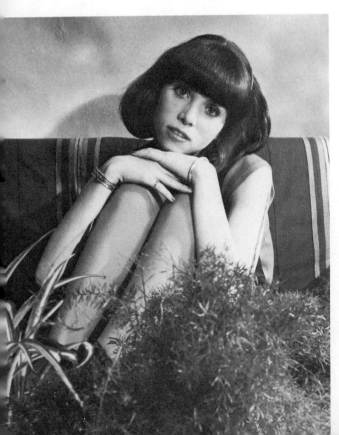

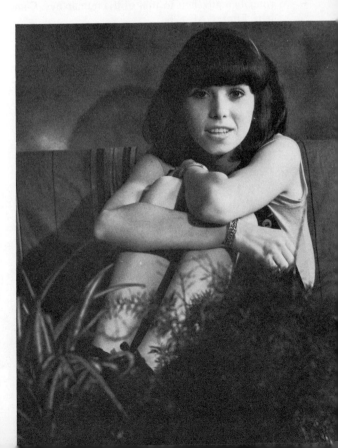

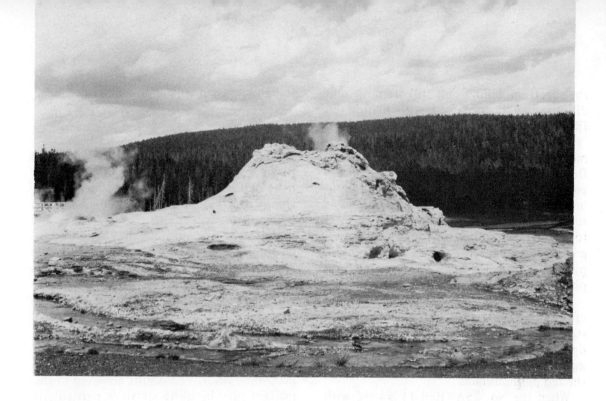

2-7a. No filter.

2-7a & b. One of the most frequent pictorial uses of a No. 25A (Red 1) filter
 is to darken blue skies to bring out clouds for drama or mood effects.

2-7b. No. 25A (Red 1) filter.

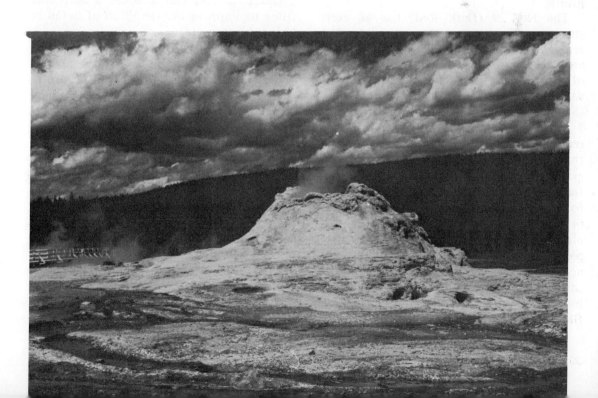

the spectrum. Milder but still dramatic renditions may be obtained with lighter red filters, which transmit both red and orange.

The No. 23A (Light Red) is not recommended for photographing people because flesh tones are rendered chalky. Its principal applications are sky darkening and enhancement of detail in reddish subjects such as rosewood furniture. It may be used to lighten red foliage or rocks and darken green foliage in scenic and nature photography. It is especially useful in architectural photography.

The No. 25A (Red 1) creates dramatic effects, greatly darkening blue skies and stormy water. Yellow objects will appear lightened by this filter, because yellow is made up of both red and green light, and the red predominates.

When the No. 25A (Red 1) is used with infrared film, blue skies will be rendered black and green foliage appears almost white due to the Wood Effect described below. It is extremely effective for cutting through fog, haze, and mist. It has a number of uses in scientific and medical photography, and it is excellent for copying blueprints.

The No. 29 (Dark Red) has an even stronger effect, especially with extended red-sensitive panchromatic films. All red areas in a scene are strongly lightened, and other areas are equally darkened. This results in maximum contrast and photographs that often have considerable graphic impact.

There is one exception to the rule that red filters darken all colors but red. This is the Wood Effect. Vivid green foliage and grass reflect a large amount of invisible infrared light. The green appearance of plants to the eye is due to the selective absorption of blue and red wavelengths by the chlorophyll. However, this absorption is not complete. Deep red and infrared rays are actually reflected from the colorless cell tissues. When other colors are held back by using a deep red or infrared filter, and the film is given sufficient exposure, healthy green plants can appear almost white.

Blue Filters

The No. 47 and No. 47B (Dark Blue) filters transmit only a narrow band of blue light and absorb almost completely everything from yellow-green to red. They can be used to accentuate haze and fog, and under certain conditions, they may be used to improve contrast. For example, in the dry air found in American deserts, there is often no appreciable moisture. Under these circumstances, photographs taken by twilight, which is essentially blue light, will exhibit greatly improved contrast between rocks that reflect blue and foliage that absorbs it, when photographed through a deep blue filter. The results achieved in this manner may be quite startling, particularly when compared with the flat greys of a similar unfiltered shot.

When used with a panchromatic or orthochromatic film, blue filters give the same tonal reduction as blue-sensitive materials. This is an asset in certain types of photographic copying which are detailed in Chapter 7. You can also use a deep blue filter to improve the rendition of detail in blue subjects.

In technical photography, the No. 47 is a blue primary-color filter used in making separation negatives for dye-transfer prints. The No. 47B is a standard, blue primary filter for making color separation negatives from original subjects, reflection copy, color transparencies, and color negatives.

Filter factors for the No. 47 are $5\times$ ($2\frac{1}{3}$ f/stops) in daylight and $8\times$ (3 f/stops) in tungsten illumination. Factors for the No. 47B are $8\times$ (3 f/stops) in daylight and $16\times$ (4 f/stops) in tungsten light with panchromatic film.

Green Filters

Aside from their use as correction filters for panchromatic film, discussed earlier, the No. 11 and No. 13 filters which are

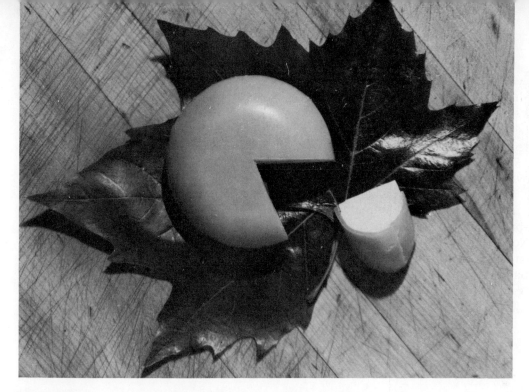

2-8a. No filter.

2-8a & b. Because most greens in nature reflect substantial amounts of red light, the No. 58 (Dark Green) filter usually produces significant, but not excessive, lightening of foliage. For this reason it is a very useful filter in landscape photography. It also dramatically darkens red, particularly an artificial red such as the coating on a round of Gouda cheese.

2-8b. No. 58 (Dark Green) filter.

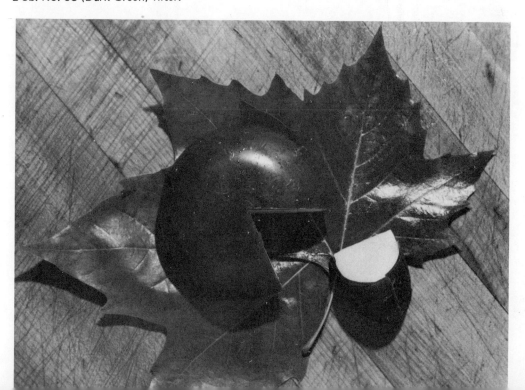

actually yellow-green filters, are most often used to differentiate green tones. These filters are especially useful in spring and early summer when there are thousands of different shades of green in delicate gradations. The No. 56 (Light Green) may also be used to improve rendition of flesh tones in portraiture. In copying with panchromatic film, it can be used to eliminate the greenish-brown lines of graph paper.

The No. 61 (Dark Green) is a primary green that is designed primarily for making color separation negatives from color transparencies and negatives. It has a factor of 12X ($3\frac{1}{2}$ f/stops) in daylight or tungsten light. In nature photography, it produces very light foliage and extreme darkening of reds; hence, it is useful for separating red fruits and blossoms from surrounding foliage.

The No. 58 (Dark Green) is a primary green for making color separation negatives directly from original subject. It has a filter factor of 8X (3 f/stops) in daylight or tungsten light. In general photography, it can be used as a contrast filter in the same way as the No. 61, but it requires 1/2 stop less exposure increase.

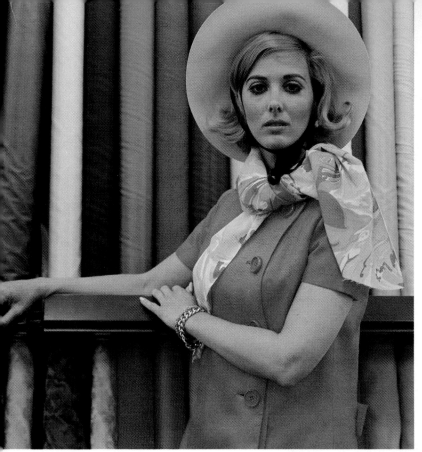

C1a & b. Photographs taken under fluorescent lighting often have a green, yellow, or blue cast depending on the type of film used and the specific fluorescent lamps. Tiffen FLB® and FLD® filters correct these color casts and provide pleasing renditions. FLB® filters are used with tungsten film (Type B) and FLD® filters are used with daylight film. Photo courtesy of Tiffen Manufacturing Corporation.

C1a. No filter.
Film: Ektachrome 6116, Type B.

C1b. FLB® filter.
Film: Ektachrome 6116, Type B.

C2a. No filter.

C2a, b, & c. Double or triple exposures through tri-color filters cause moving subjects, such as water, to break up into multiple colors while stationary subjects appear "normal." Registration of each exposure must be exact, so a camera with multiple-exposure capability is required. Camera: GAF L-CS. Film: GAF 64. See Chapter 6 for exposure recommendations.

C2b. Successive exposures through No. 25A (Red 1) and No. 47B (Dark Blue) filters give a magenta cast to stationary subjects. Moving water is broken up into blue, magenta, and red areas.

C2c. Successive exposures through No. 25A (Red 1), No. 47B (Dark Blue), and No. 58 (Dark Green) filters produce a prismatic effect.

C3a. Standard color rendition using Kodachrome II without filter.

C3a, b, & c. For offbeat effects, try color infrared film, which should be used with a No. 12 (Yellow) for scientific work, although a No. 8 (Yellow 2), No. 9 (Yellow 3), or No. 15 (Deep Yellow) will produce similar effects. Normal foliage is rendered red or yellow and sky is blue. By using other filters you can achieve different results. Camera: Topcon DM with 50mm lens.

C3b. Tiffen No. 12 (Yellow) filter with Ektachrome Infrared Film (below right).

C3c. Tiffen No. 25A (Dark Red) filter with Ektachrome Infrared Film turns blue sky green (below).

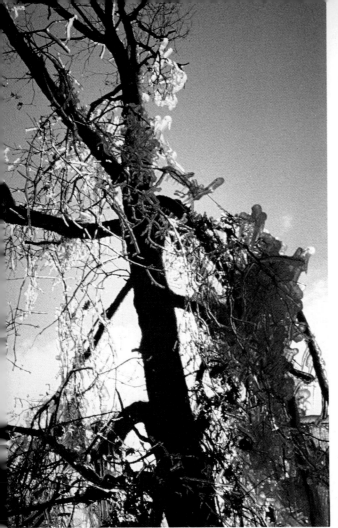

C4a. No filter.

C4a & b. Unusual color effects can be achieved by using deep color filters, particularly if the subject works well as a silhouette. In the backlighted photo of a tree covered with ice, the 47B (Dark Blue) filter provides an interpretation that emphasizes the cold quality of the ice. Camera: GAF L-ES with 35mm lens. Film: GAF 500.

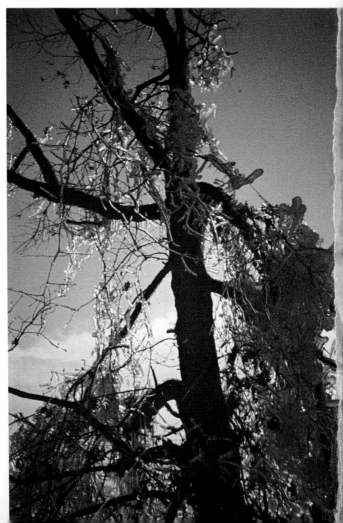

C4b. Tiffen 47B (Dark Blue) filter.

C5a. No filter—straight duplication.

C5b. Filter 81C used to produce warm
tones.

C5a & b. Filters can be used when
slides are being duplicated to create
interesting variations of unfiltered
shots. The reproductions here were
made from 35mm duplicates of a
6 X 7 original that was shot on High
Speed Ektachrome daylight film.

C6a. No filter.

C6a & b. Unfiltered photographs made in open shade under a blue sky usually have a bluish cast that can be corrected by using a reddish filter, such as the 81B or R1½. Camera: Nikon FTN with 85mm lens. Film: High Speed Ektachrome. Photos by Kathleen Benveniste.

C6b. Tiffen R1½ DM filter.

C7a. No filter.

C7a & b. Polarizing filters, in addition to effectively reducing
glare and reflections, also greatly improve color saturation.
Camera: Pentax Spotmatic with 28mm lens. Film: Kodachrome 25.

C7b. Tiffen SR Polarizer.

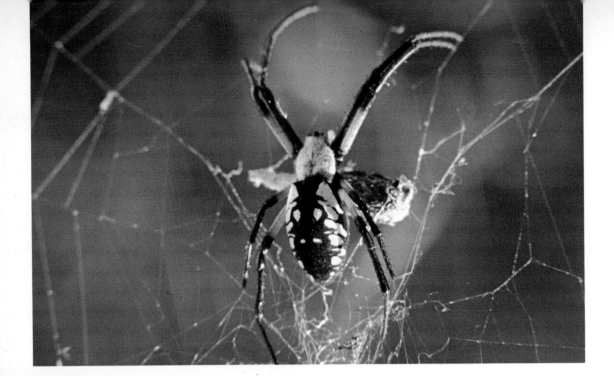

C8. When using close-up lenses, image size depends on both the diopter of the attachment lens and the focal length of the camera lens. To make this photo, a +4 close-up lens was used with a 135mm prime lens to produce adequate image size while keeping a comfortable distance between the lens and the spider. Camera: Pentax Spotmatic. Film: Kodak High Speed Ektachrome.

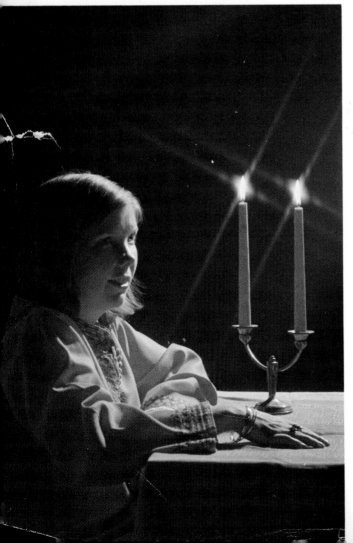

C9. For optimum star effects, a point source of light, such as a candle, can be imaged against a dark background with as much distance as possible between camera and subject. In this studio photo, additional light for the face was provided by a spotlight. Camera: GAF L-ES with a 135mm lens. Film: GAF 200 with Tiffen B12 plus B1½ DM filters, and Tiffen 4-point star filter, 3mm grid.

3

Filters for Color Photography

In black-and-white photography, fairly strong filters must be employed before a scene loses its "natural" appearance. Color, on the other hand, is an entirely different matter. Minor changes in lighting quality, such as the sun hiding behind a cloud or exposure through a very pale filter, can produce startling changes in overall image color, particularly with color-slide film. With color-print film, such changes become less obvious because variations in lighting quality can be compensated for during print making.

This chapter deals first with the basic principles of filtration in color photography, including the varying requirements for different types of film. Succeeding sections detail the ways in which you can use filters from the basic groups of color filters to achieve consistent, high-quality results from all types of color film.

FAITHFUL COLOR RENDITION

Most of us have on occasion noticed how the color of familiar things will change according to the prevailing light. The warm quality of lips and skin seen by candlelight, for example, may alter dramatically when viewed by fluorescent lights. Mentally we accept these, and many other less dramatic changes, as normal, and quickly adjust to them.

Color film does not share our adaptability. Each type will theoretically provide correct color rendition under only one type of illumination, although considerable latitude is possible in non-critical, amateur photography. If accurate color rendition is desired, filtration is a must when the lighting quality varies from that for which the film was designed.

Daylight-type color films are designed to respond best to the mixture of sunlight and skylight that occurs in middle latitudes around noon on a bright summer day. Films such as Fujichrome, Kodachrome 25, GAF 64, High Speed Ektachrome, Agfa 64, GAF 500, and so on are all balanced for this type of light. The term *balanced* refers to the fact that modern color films are composed of three layers that respond to blue, green, and red light. The sensitivity of these layers is balanced so that the proportions of red, green, and blue light found in the standard light source (noon skylight plus sunlight for daylight-type films) will produce correct color. When the proportions of red, green, and blue in the light vary from the standard, a different rendition results unless a filter is used to adjust the proportions of color that strike the film.

The standard artificial light sources are photographic lightbulbs with tungsten filaments that produce light that is somewhat

brighter and more bluish than ordinary household bulbs. These are referred to as tungsten or tungsten-halogen (quartz) lamps, and the quality of their light is measured by the color temperature scale in Kelvin (K) units. On this scale, the standard light for Type A color film is a photoflood lamp with a color temperature of 3400 K. Kodachrome Type A and most amateur Super 8 color movie films are of this type.

The standard light for a Tungsten Type film (designated Type B) is a studioflood lamp with a color temperature of 3200 K, which is slightly warmer, that is, more reddish, than a photoflood lamp. High Speed Ektachrome, Tungsten (Type B), is balanced for use with 3200 K lamps, as are many of the professional color films designed for studio work. (For additional information on color temperature, see the sections on "Light-Balancing Filters" and "Decamired Filters.")

Color print films are usually balanced for daylight, blue flashbulbs, and electronic flash. There are other special films that are balanced midway between daylight and photoflood, such as Kodak Ektachrome 160 Type G movie film, which is intended to produce acceptable, but non-critical, color in most situations. As a rule, color is most critical when you are making color transparencies or slides, particularly if they will be viewed in sequence, in which case differences in color quality from one shot to the next become very apparent. Color print film gives you considerable latitude, because even major changes in color quality can be adjusted in the darkroom when the print is made.

Today, most amateur motion-picture cameras have a built-in filter that is in place behind the lens for outdoor shooting and automatically moves out of the way for indoor photography when you attach a movie light to the camera, place a screw in the movie-light socket, or press the filter button, depending on camera design. Additional filters can be used in front of the lens for minor color adjustments if the photographer thinks it important. In professional motion-picture work, filters are considered a necessity, since standards are far more critical than those in amateur work.

The filter corrections that are recommended within this chapter will produce the most consistent results when you are working with color-slide film or motion-picture film Variations in the quality of color prints are frequently due to the variables inherent in mass photofinishing operations and may disappear when the same negatives are printed in a custom photo laboratory.

UV, SKYLIGHT, AND HAZE FILTERS

The bluish cast that often appears like a veil over unfiltered photographs made at the beach, in the mountains, or on hazy days is due to invisible ultraviolet radiation to which all film is sensitive. In general photography this radiation constitutes a minor nuisance that can be easily controlled by using an Ultraviolet (UV), Skylight (1A), or Haze (1 or 2A) filter.

The Skylight 1A is deservedly the most popular color filter because it not only filters out ultraviolet radiation, but also adds warmth to a scene, which helps prevent a bluish cast when you are photographing under hazy or cloudy skies or in the shade. It provides mild haze penetration and is the first filter most photographers buy for color work. There are only two disadvantages you may encounter with this filter: First, it warms a scene slightly and your personal taste may dictate a cooler rendition; second, pale flesh tones in portraits made in open shade with some European color films may appear slightly muddy, in which case a Haze 1 is a better choice.

The Haze 1 has a slightly stronger effect than the Skylight 1A. It effectively reduces excess blue caused when ultraviolet light is scattered by particles in the atmosphere, and it therefore has a haze penetrating ef-

Filter No.	Film Type	Lighting	f/Stop Increase	Suggested Uses
SKY 1A	Daylight	Daylight	—	Use at all times, outdoors, to reduce blue and add warmth to scene. Also in open shade
HAZE 1	Daylight	Daylight	—	Reduce excess blue caused by haze and ultraviolet rays. Ideal for mountain, aerial, and marine scenes
HAZE 2A	Daylight	Daylight	—	Greater ultraviolet correction than Haze No. 1 filter and adds some warmth to the visible colors
UV15	Daylight	Daylight	—	Haze filter, also for 3200K film with photofloods
UV16	Daylight	Electronic flash Daylight	—	Reduces excessive blue in electronic flash, also may be used for haze correction
UV17	Daylight	Daylight	—	Greater haze correction, reduces blue in shade
3(Aero 1)	Daylight	Daylight	$^2/_3$	Aerial photography for haze penetration

fect. It is ideal for mountain, aerial, and marine scenes with films that tend to give a cool color rendition.

The Haze 2A is slightly stronger than the Haze 1. It has a greater haze penetrating effect and adds more warmth to visible colors, particularly to pale flesh tones and other pastel shades.

The faintly yellow UV15, UV16, and UV17 filters have progressively greater effects, and they may impart a slight yellow cast to some films. They are excellent haze penetrating filters for use when strong haze penetration is required. They can all be used to reduce excessive blue in photographs made with electronic flash. The UV17 is generally recommended for use with those electronic flash units that do not have a built-in UV filter over the light source or a "gold" tube.

Selection of a filter depends in part on photographic intent, personal taste, and experience with the film you are using. The Skylight 1A or Haze 1 are good general-purpose filters. Where maximum haze penetration is desired for scenic or aerial photography, a Haze 2 or one of the stronger UV filters could be chose, providing clarity of detail at the expense of a slightly warmer color rendition, which in most cases is quite acceptable.

The skylight, UV, and haze filters can all be used without exposure compensation.

CONVERSION FILTERS

Conversion filters allow you to get correct color when you use daylight-type film with photoflood or studioflood lights, or when you use a tungsten-type film in daylight. These filters have fairly deep colors that produce the major changes required when "converting" from outdoor to indoor standards, or from indoor to outdoor standards.

When a daylight film is used to take pictures by photoflood, studioflood, or general-service household lightbulb illumination and no filter is used, the photo will have a deep reddish or yellowish cast. If the light source is a 3400 K photoflood lamp or movie light, the 80B filter produces the required color correction. If the light source is a 3200 K studioflood, use an 80A filter for correction. The 80A should also be used if you are photographing by the light of standard household lightbulbs or stage lights, although additional correction with light-balancing or Decamired filters (described in the following sections) may be desirable.

The 80A and 80B filters both require an exposure increase of 2 f/stops (4X).

When you use a daylight film with aluminum foil-filled clear flashbulbs, and 80C filter will provide the appropriate correction. The filter requires an exposure compensation of 1 f/stop (2X). It can also be used when strong correction is required outdoors in early morning or late afternoon sunlight. The 80D filter is similar to the 80C but not as strong. It is used to correct zirconium foil-filled clear flashbulbs for use with daylight film. It requires an exposure increase of 1/3 f/stop.

When an indoor or tungsten-type film is used to take photographs by daylight and no filter is used, the resulting photos will have a deep blue cast because daylight has much more blue light in it than the lamps for which these films are balanced. With Type A film, an 85 filter produces the required correction. This type of filter is built in to most amateur Super 8 and Single 8 movie cameras, but a separate filter is required for all other types of cameras. To convert Type B tungsten film to daylight, use an 85B filter.

To compensate exposure for the light absorbed by the No. 85 or No. 85B, open up the lens 1/2 f/stop (1.5X), or use a through-the-lens exposure reading. (Exposure compensation is automatic with most amateur Super 8 cameras.) The relatively low exposure factor required when converting from indoor standards to daylight explains why indoor color film has become the all-purpose film for movie-making.

The accompanying chart summarizes the Tiffen series of conversion filters and provides the precise conversion in degrees Kelvin and in Mireds, which are explained in the section of Decamired filters.

LIGHT-BALANCING FILTERS

Light-balancing filters are designed to make minor changes in the quality of light striking the film so that annoying bluish or reddish casts are eliminated. Technically,

they make slight adjustments in the proportions of red, green, and blue light which can bring the spectral distribution of the light source back to the standard for which the film is balanced.

There are two series of light-balancing filters—the bluish 82 series, which cool the light, and the warming 81 series of yellowish filters. Outdoors, the warming filters from the 81 series are selected to add warmth in cloudy, overcast, or open shade (subject illuminated by blue skylight) situations. Indoors, these filters can be used to adjust the light from small arc lamps used in photomicrography to tungsten-type films and warm the light from photofloods for use with tungsten-type film.

The cooling 82 filters are used outdoors to correct for the warmth of early morning or late afternoon sunlight, and compensate for the naturally warm rendition of some films, according to the photographer's personal taste. Indoors they can be used to correct the warm rendition produced by general-service household bulbs or old photoflood and studioflood lamps that change in color temperature with use.

In practice, you may find that slightly more or less filtration will suit your personal tastes. The warmth or coolness of a transparency will vary, depending on the film type, lighting at the time of exposure, and the light in which the finished transparency is viewed. A small slide viewer with a built-in light source is generally quite warm, a projector somewhat cooler. A professional light box designed for transparency viewing is quite cool—close to daylight (5000 K) in fact. In selecting your filter requirements, keep in mind the viewing conditions, and if possible, standardize the viewing situation—either a slide projector for home or professional slide presentations or a light box for reproduction.

A convenient way to familiarize yourself with the effect of light-balancing filters, singly and in combination, is to arrange a series of unfiltered slides taken under a

TIFFEN CONVERSION FILTERS FOR COLOR FILMS

Filter Color	Filter Number	Exposure Increase in f/stops	Application	Lighting Conversion in Kelvin Units	Decamired Shift Value
Blue	80A	2	Balances daylight film with studio-floods. Also used for general-service household bulb.	3200K to 5500K	−13.1
Blue	80B	$1^2/_3$	Balances daylight film with photo-floods.	3400K to 5500K	−11.2
Blue	80C	1	Balances clear, aluminum foil-filled flash with daylight.	3800K to 5500K	−8.1
Blue	80D	$^1/_3$	Balances clear, zirconium foil-filled flash with daylight.	4200K to 5500K	−5.6
Amber	85C	$^1/_3$	Balances daylight films for use with clear flash	5500K to 3800K	8.1
Amber	85	$^2/_3$	Balances Type A film with daylight.	5500K to 3400K	11.2
Amber	85B	$^2/_3$	Balances Tungsten (Type B) film with daylight.	5500K to 3200K	13.1

variety of lighting conditions and view them through various filters. You can do this by holding filters in front of a projector lens or by viewing through the filter an assortment of slides laid out on a light box or slide-sorter.

In advertising photography and motion-picture work, where color consistency is important, professionals sometimes use a color-temperature meter to determine exactly which filter will give standard color rendition. The less-expensive color-temperature meters measure the proportion of red and blue in the light and provide a reading that can be converted to either light-balancing or Decamired filter requirements. They are intended for use only with tungsten lights. More expensive meters can often measure red, blue, and green, which permits their use outdoors or with fluorescent lights.

Light-balancing filters may be used in combination for stronger effects, although exact effects will be difficult to predict unless you use the mired system described in the following section on Decamired filters. The accompanying chart of light-balancing filters describes their effect in terms of color-temperature corrections and mired shift values.

Exposure Factors

No exposure compensation is required with the 81, 81A, 81B, and 81C filters; however, if exposure is considered critical, a 1/3 f/stop exposure increase can be used. With the two strongest filters in this series, the 81D and 81EF, a 1/2 f/stop can be used for general work, or a 2/3 f/stop increase for more critical work. (The difference in suggested exposure lies in the ease of adjustment: Most lenses can easily be adjusted for 1/2 f/stop changes; 1/3 f/stop intervals are more accurate, but difficult to make.)

For the bluish 82 series, no exposure increase is required for the 82 or 82A, although a 1/3 f/stop increase may be used

LIGHT-BALANCING FILTERS

Filter Color	Filter Number	Exposure Increase in f/stops*	To obtain 3200K from	To obtain 3400K from	Decamired Shift Value
Bluish	82C + 82C	$1^1/_3$	2490 K	2610 K	−8.9
	82C + 82B	$1^1/_3$	2570 K	2700 K	−7.7
	82C + 82A	1	2650 K	2780 K	−6.5
	82C + 82	1	2720 K	2870 K	−5.5
	82C	$^2/_3$	2800 K	2950 K	−4.5
	82B	$^2/_3$	2900 K	3060 K	−3.2
	82A	$^1/_3$	3000 K	3180 K	−2.1
	82	$^1/_3$	3100 K	3290 K	−1.0
No Filter Necessary			3200 K	3400 K	−
Yellowish	81	$^1/_3$	3300 K	3510 K	.9
	81A	$^1/_3$	3400 K	3630 K	1.8
	81B	$^1/_3$	3500 K	3740 K	2.7
	81C	$^1/_3$	3600 K	3850 K	3.5
	81D	$^2/_3$	3700 K	3970 K	4.2
	81EF	$^2/_3$	3850 K	4140 K	5.2

*These values are approximate. For critical work, they should be checked by practical test, especially if more than one filter is used.

as a starting point for critical work. An increase of 1/2 f/stop is recommended for the 82B and 83C filters (2/3 f/stop increase for more critical work).

To find the exposure increase for light-balancing filters used in combination, add together the increase in f/stops required for each filter.

DECAMIRED FILTERS

Owning a set of Decamired (DM) filters is equivalent to owning a complete series of light-balancing and conversion filters with the added advantage of predictable results when the filters are used in combination. Predictability is built into the Mired system of color-temperature measurement on which DM filters are based.

In the Kelvin system, discussed previously, the same filter will create a greater change in color temperature at higher Kelvin numbers. For example, a reddish filter might change 2550 K to 2400 K, a difference of 150 K. But the same filter would change 10,000 K to 7700 K, a difference of 2300 K. These variations make the Kelvin system hard to use in practical photography, and when you consider that the warming produced by the filter is visually identical, despite the differences in color temperature, the complexity of the Kelvin system becomes evident.

The solution to this problem was the development of a color-temperature scale in which the warming or cooling effect of a filter would be accurately indicated by a single number. Hence, the Mired system of color-temperature measurement was developed.

In the Mired system, the difference between 2550 K (390 mireds) and 2400 K (420 mireds) is 30 mireds. The difference between 10,000 K (100 mireds) and 7700 K (130 mireds) is also 30 mireds. So any filter or combination of filters producing a 30-mired shift will give consistent results when color temperatures are measured in mireds.

In the Mired system, 10 mireds equals one decamired. Since mireds are fairly small units, and a shift of 10 mireds is the smallest change generally used in photography, it is convenient to use decamireds for numbering filters. In charts throughout this chapter, you will find color-temperature measurements given in decamireds as well as in Kelvins. The accompanying table gives the average decamired value of typical light sources used in photography.

A Tiffen DM filter set contains four reddish, or warming, filters—R1$\frac{1}{2}$, R3, R6, and R12—and four bluish, or cooling, filters—B1$\frac{1}{2}$, B3, B6, and B12. The letter in the filter designation refers to the filter's color and the number gives its decamired value.

DM filters can be combined to achieve a variety of DM values; however, you can only combine filters of the same color.

MIRED VALUES OF COLOR TEMPERATURES FROM 2000-6900 K

Kelvin Units	0	100	200	300	400	500	600	700	800	900
2000	500	476	455	435	417	400	385	370	357	345
3000	333	323	312	303	294	286	278	270	263	256
4000	250	244	238	233	227	222	217	213	208	204
5000	200	196	192	189	185	182	179	175	172	169
6000	167	164	161	159	156	154	152	149	147	145

COLOR TEMPERATURE OF COMMON LIGHT SOURCES

SOURCE	COLOR TEMPERATURE (KELVIN UNITS)	APPROXIMATE DECAMIRED VALUE
Clear blue northern skylight	15,000-27,000	6-4
Subject in shade, illuminated by blue skylight	10,000-12,000	9
Hazy skylight	7500-8400	12
Overcast sky	6700-7000	15
Electronic flash	6200-6800	16-15
Blue flashbulb	6000	17
Hazy sunlight	5800	17
Average daylight	5500-6000	18-17
Morning or afternoon sunlight	5000-5500	19
500-watt blue photoflood	4800-5400	21-19
Clear zirconium foil-filled flashbulbs	4200	24
Clear aluminum foil-filled flashbulbs	3800	26
500-watt amateur photoflood lamps	3400	29
500-watt studioflood lamps	3200	31
100-watt general-service lightbulb	2900	35
75-watt general-service lightbulb	2820	35
40-watt general-service lightbulb	2650	38

Blue and red can not be mixed. To find the effect of a filter combination, just add their mired values. For example, an R3 plus an R6 filter are equivalent to an R9 filter.

Filter factors for DM filters are given in the accompanying chart. To find the exposure compensation necessary when using DM filters in combination, add the increase in f/stops required for each filter. (If you are using filter factors, multiply the factors.)

When you work out combinations of light and filters, you will find that not all values fall exactly on a filter number or combination of filters in your set. In this case, the general rule is that you use the next lower filter number or combination of numbers.

You can calculate DM filter requirements by using the chart of color temperatures as a guide. The lower the decamired value, the cooler the light; the higher the decamired value, the warmer the light. To warm the light, that is raise its decamired value, use R filters; to cool, or lower the decamired value, of a light source, use the B filters.

DECAMIRED EXPOSURE INCREASE

R Series	Exposure Increase in f/stops
R 1-$\frac{1}{2}$	$\frac{1}{4}$
R3	$\frac{1}{3}$
R6	$\frac{1}{2}$
R3 + R6 = R9	$\frac{3}{4}$
R12	1
R12 + R3 = R15	1-$\frac{1}{3}$
R12 + R6 = R18	1-$\frac{1}{2}$

B Series	Exposure Increase in f/stops
B 1-$\frac{1}{2}$	$\frac{1}{4}$
B3	$\frac{1}{2}$
B6	1
B3 + B6 = B9	1-$\frac{1}{2}$
B12	2
B12 + B3 = B15	2-$\frac{1}{2}$
B12 + B6 = B18	3

To find the correct DM value, subtract the DM value of your light source from the DM value of the film. If the result is a positive number, use an R filter; if the result is negative, use a blue filter. For example, some daylight color films are balanced for 18DM. If you are photographing on an overcast day, the DM value of the light is about 15. Since 18DM−15DM= 3DM, which is a positive number, you would use an R3 for correction. If you wanted to convert daylight film to studiofloods, which have a color temperature of 31DM, subtract 31 from 18, which gives −13 (18DM−31DM= −13DM). In this case you would select the nearest blue (negative) filter, which is the B12.

Although most daylight films are balanced for 18DM, some give slightly warm results and are in fact balanced for 17DM. Kodachrome II Type A film is balanced for approximately 29DM. Other tungsten films are balanced for 31DM.

When DM filters are used outdoors with daylight film the slight bluish cast due to hazy conditions can be corrected with an R1$\frac{1}{2}$. For greater correction in cloudy weather, try an R3. If a daylight film gives renditions that, in your opinion, are slightly warm, try the B1$\frac{1}{2}$. This filter can also be used to provide partial correction for the warm early morning or late afternoon sunlight. For greater correction, try the B3. To convert daylight film for use with photoflood lights (3400 K or 29DM), try a combination of B3, B6, and B1$\frac{1}{2}$. To convert daylight film for use with studioflood lights (3200 K or 31DM), use a B12 filter. To use tungsten film in daylight, use an R12 filter.

Indoors, the B series can be used when photographing with general-service household bulbs. For example, a new 100-watt bulb has a DM value of about 34$\frac{1}{2}$ (about 2900 K), whereas tungsten-type film is balanced for 29DM-31DM. A B3 + B1$\frac{1}{2}$ will produce adequate color correction. If the bulb is old, the color temperature

DECAMIRED FILTER SELECTOR CHART*

FILM TYPE	LIGHTING	FILTER	EXPOSURE INCREASE IN f/STOPS
DAYLIGHT	Bluish daylight, open shade, slight overcast, blue flashbulbs	R1-$\frac{1}{2}$	$\frac{1}{4}$
	Electronic flash	R3	$\frac{1}{3}$
	Average sunlight plus skylight	None	—
	Early morning or late afternoon sunlight	B1-$\frac{1}{2}$	$\frac{1}{4}$
	Clear flashbulbs	B6 + B1-$\frac{1}{2}$	1-$\frac{1}{4}$
	3400 K photofloods	B3 + B6 + B1-$\frac{1}{2}$	2
	3200 K studiofloods	B12	2
	100-watt lightbulb	B12 + B3	2-$\frac{1}{2}$
TYPE A (BALANCED FOR 3400K LAMPS)	Bluish daylight, open shade, slight overcast	R12 + R3	1-$\frac{1}{3}$
	Electronic flash and blue flashbulbs	R12	1
	Average sunlight plus skylight	R3 + R6 + R1-$\frac{1}{2}$	1
	Late afternoon or early morning sunlight	R3 + R6	$\frac{3}{4}$
	Clear flashbulbs	R3	$\frac{1}{3}$
	3400 K photofloods	None	—
	3200 K studiofloods	B1-$\frac{1}{2}$	$\frac{1}{4}$
	100-watt lightbulb	B6	1
TUNGSTEN (TYPE B) (BALANCED FOR 3200 K)	Bluish daylight, open shade, slight overcast	R12 + R3 + R1-$\frac{1}{2}$	1-$\frac{1}{2}$
	Electronic flash and blue flashbulb	R12 + R3	1-$\frac{1}{3}$
	Average sunlight plus skylight	R12	1
	Late afternoon or early morning sunlight	R1-$\frac{1}{2}$ + R3 + R6	1
	Clear flashbulbs	R3 + R1-$\frac{1}{2}$	$\frac{1}{2}$
	3400 K photofloods	R1-$\frac{1}{2}$	$\frac{1}{4}$
	3200 K photofloods	None	—
	100-watt lightbulb	B3	$\frac{1}{2}$

*Filter suggestions given here should be considered as starting points for correction only. More or less filtration may be required to suit personal tastes.

may have warmed up slightly, in which case a B6 filter could be used. To get correct color with daylight film and a 100-watt bulb, use a B12 + B3 + B1½.

Additional suggestions for using DM filters are given in the accompanying chart.

In the United States, color temperature is most often given in degrees Kelvin. To convert Kelvins to mireds, divide one million by the color temperature in Kelvins. The result is the mired value. To get the DM value, divide the mired value by 10. For example, Kodachrome 25 is balanced for 5500 K. To find its DM value, make the following calculations:

1,000,000 ÷ 5500 K = 182 mireds
182 mireds ÷ 10 = 18 decamireds (rounded off to the nearest whole number)

FLUORESCENT LIGHT FILTERS

Fluorescent lights present a special photographic problem because they do not have a standard distribution of red, blue, and green light. As a result, unfiltered photographs taken under fluorescent light will usually have a blue-green or yellow-green cast.

These unwanted color casts can be readily eliminated by using the Tiffen filters for fluorescent lights. The FLB® filter is used with tungsten films and the FLD® filter with daylight films. These filters are all you need for general photography under fluorescent illumination. They can also be used for combination daylight and fluorescent or tungsten and fluorescent situations with generally pleasing results. The slightly warm rendition of the non-fluorescent light is an acceptable compromise when the main source of illumination is fluorescent.

Increase exposure 1 f/stop when using either the FLD® or FLB® filter. Use a shutter speed of 1/60 sec. or slower to ensure even illumination and color quality. because fluorescents vary during each AC cycle.

COLOR COMPENSATING FILTERS

Color compensating (CC) filters are available in varying densities of yellow, magenta, cyan, red, green, and blue. One of their principal applications in camera work is to make minor adjustments to compensate for batch-to-batch variations in color film when critical standards of color balance are required. These filters can also be used to adjust the color balance of unusual light sources, and to change color quality for pictorial effect.

CC filters are also used with color slide films when extremely long exposures are likely to change the color balance of the film. This shift in color is termed *reciprocity failure*, and manufacturers of slide films often supply recommended combinations of CC filters that will provide correct color when long exposures are required.

In the photographic laboratory, CC filters can be used for color print making and for altering color casts during slide duplicating.

Color compensating filters are identified by density (depth of color) and color. For example, in the CC30M filter designation, CC stands for color compensating, 30 for a density of 0.30, and M for magenta. The accompanying chart shows the available Tiffen CC filters and the exposure increase required for each one. They may be used singly or in combination to produce a wide variety of effects.

The CC filter most widely used in general photography is the CC30R, which corrects color distortion when you are photographing through transparent plastic windows, such as the vistadomes on some railroad cars. This filter can also be used underwater to provide full or partial color correction, depending on the water quality, depth, and lighting.

Various combinations of CC filters are recommended by manufacturers of color film as a means of correcting for fluorescent lighting. However, precise color under

TIFFEN COLOR COMPENSATING FILTERS

Density	Red (Absorbs Blue and Green)	Exposure Increase in f/stops*	Green (Absorbs Blue and Red)	Exposure Increase in f/stops*	Blue (Absorbs Red and Green)	Exposure Increase in f/stops*
.05	CC05R	$^1/_3$	CC05G	$^1/_3$		
.10	CC10R	$^1/_3$	CC10G	$^1/_3$	CC10B	$^1/_3$
.20	CC20R	$^1/_3$	CC20G	$^1/_3$	CC20B	$^2/_3$
.30	CC30R	$^2/_3$	CC30G	$^2/_3$		
.40	CC40R	$^2/_3$	CC40G	$^2/_3$		
.50	CC50R	1	CC50G	1	CC50B	$1^1/_3$

Density	Yellow (Absorbs Blue)	Exposure Increase in f/stops*	Magenta (Absorbs Green)	Exposure Increase in f/stops*	Cyan (Absorbs Red)	Exposure Increase in f/stops*
.05	CC05Y	none	CC05M	$^1/_3$	CC05C	$^1/_3$
.10	CC10Y	$^1/_3$	CC10M	$^1/_3$		
.20	CC20Y	$^1/_3$	CC20M	$^1/_3$		
.30	CC30Y	$^1/_3$	CC30M	$^2/_3$		
.40	CC40Y	$^1/_3$	CC40M	$^2/_3$		
.50	CC50Y	$^2/_3$	CC50M	$^2/_3$	CC50C	1

*For critical work exposure compensation should be checked by practical test.

fluorescents depends on the type of the tubes and their age. Moreover, many fluorescent lighting fixtures with more than one tube contain a mixture of tube types. Tests using various filter combinations are generally required to find the precise combination needed. Unless color is critical, these tests are rarely worth bothering with. A Tiffen FLB® or FLD® filter will give satisfactory results in most situations.

4

Special-Purpose and Special Effect Filters

All of the special-purpose filters and most of the special-effects filters discussed in this chapter can be used with either black-and-white or color films. In the special-purpose category are polarizers and neutral density filters, both of which play important roles in general and technical photography.

As the category name implies, special-effects filters are used to modify the image by creating star-bursts of light, soft-focus or fog effects, and other unusual variations on the standard photographic image.

SPECIAL-PURPOSE FILTERS

Polarizing Filters

The polarizer is a workhorse filter that finds application in all areas of photography with all types of film. It can be used to deepen the color of blue skies; increase color saturation in scenic photographs; and reduce or eliminate glare and reflections from water, glass, and other smooth surfaces. In color photography it can even function as a haze filter.

Tiffen manufactures two types of polarizing filter. The first is the Tiffen SR Polarizer, which is a complete polarizing filter that consists of two parts: a front section containing the filter itself, and a rotating mount that turns inside the rear part that

screws into the filter mount on the lens or fits into a series-size adapter ring. The SR Polarizer is no bigger than an ordinary filter and lets you screw additional filters or lens accessories into its front thread. It fits all popular 35mm single-lens reflex cameras as well as 8mm and 16mm reflex movie cameras with regular zoom lenses.

The second type of polarizer is a filter disc that slips into a series adapter like any other filter. A directional arrow engraved on the rim of the filter can be used as a guide to positioning the filter for maximum effect.

Unlike most other filters, the effect of a polarizer does not depend on the color of light, but on the wave nature of light. Each ray of non-polarized light vibrates in all directions around its axis of travel. When this light is reflected from a blue sky or from a shiny surface (at an angle of about 30°), such as glass or water, the light will vibrate in one direction only. Light that vibrates in one plane is said to be "polarized."

A polarizing filter acts as a microscopic grid, or gate, that automatically passes light that is not polarized. Light that is already polarized will either be stopped or passed, depending on how the filter is turned. When the grid of the filter is turned crossways to the direction of vibration of polar-

ized light, the light is blocked. When the grid is aligned with the direction of vibration, the light will pass. By turning the filter, you can regulate the amount of polarized light that will pass through. Ordinarily, non-polarized light will pass the filter regardless of the angle at which it is turned. Because average scenes will contain mostly non-polarized light, the polarized light held back by the filter is ordinarily unwanted. For the exposure, a polarizer can be assigned a general factor of 4X (2 f/stops).

Using a Polarizer

To use a polarizer, look at your subject through the filter and rotate the filter slowly to see the range of available effects. For other effects, change your position in relation to the subject. Maximum darkening of blue sky will occur in the arc of sky that is at a 90° angle to the line between you and the sun. This maximum-effect area is lowest on the horizon around noon in summer and high in the sky around sunrise or sunset. Using a polarizer is the best way to produce deep blue skies in color photography without changing any of the other color values in the scene.

For maximum reduction of glare or reflections from smooth surfaces such as water or windows, photograph at an angle of about 30-35° to the surface. This angle will allow you to photograph through clear, shallow water to capture subjects beneath the surface or to photograph window displays without glare or reflections from the street. Paper and other non-metallic reflecting surfaces can also be photographed in this way.

Metallic surfaces are unique in that they do not polarize light, regardless of the angle of reflection. Some metallic paints may also behave in this way.

A polarizer is recommended for general use in outdoor scenic photography in sunlight because it increases color saturation by dampening glare reflected from foliage,

and helps penetrate light haze. It is the preferred filter for use in thermal areas such as those in Yellowstone National Park.

In copy photography, a polarizer can be used to reduce glare spots created by the uneven shiny surfaces of oil paintings or reflections from glossy prints. If you also use polarizers over your light sources, it is possible to eliminate almost all glare spots and reflections. For accurate exposure, the meter reading should be taken through the camera filter with all the filters rotated to the position that will be used when making the shot.

Polarizers in Combination with Other Filters

Other types of filters are frequently combined with a polarizer. For example, you may want to use a No. 8 (Yellow 2) for correction with black-and-white film, or a light-balancing filter with color film. For a dramatic night effect in daylight with black-and-white, you can combine a polarizer with a No. 25 (Red 1), which will produce dark foliage and clouds that stand out in bold relief against a nearly black sky.

For best results when combining filters, attach the polarizer to the lens first and then add the second filter. If you do not use through-the-filter metering, remember to add the exposure increase in f/stops required for each filter to find the total exposure compensation needed (alternatively, multiply the exposure factor for each filter). Thus, a polarizer, which normally requires that you open up the lens 2 f/stops (4X filter factor), and a No. 25 (Red 1) which requires a 3 f/stop (8X) exposure increase, would require a 5 f/stop exposure increase when combined (4X multiplied by 8X = 32X = 5 f/stops increase).

Tiffen offers two combination polarizing filters that are especially useful when working with professional 16mm or 35mm motion-picture equipment; however, still cameramen may also find them useful.

The 85POL combines the No. 85 filter

4-1a & b. In these photographs taken in the garden of the Museum of Modern Art in New York City, glare obscures the painting that can be seen through the window and creates a sheen on the sculpture, which alters the tonal impression. By using a Tiffen Polarizer, the photographer was able to reduce glare on the sculpture and almost completely eliminate it from the window. Camera: Nikon FTN with 85mm lens. Film: Kodak Plus-X. Photos by Kathleen Benveniste.

4-1a. No filter.

4-1b. Polarizer.

with a polarizer and converts Type A films to daylight with all the advantages of a polarizer and none of the disadvantages of using two separate filters. This filter may also be used with 8mm cameras that do not have a built-in filter.

The 85BPOL is an 85B combined with a polarizer. It converts Type B tungsten film to daylight with all the advantages of a polarizer. Both the 85POL and 85BPOL have a factor of 5X or $2\frac{1}{3}$ f/stops exposure increase.

Neutral Density Filters

Neutral density (ND) filters are used for exposure control in both black-and-white and color photography. Greyish in appearance, Tiffen ND filters reduce the amount of light passing through them, and therefore have no effect on contrast or image color. Their only action is to lessen the amount of light entering the lens so that longer exposures or wider lens apertures can be used.

Using ND Filters

Tiffen neutral density filters in series sizes are available in a range from 0.1 to 4.0, as shown in the accompanying chart. They can be used singly or in combination, and the numbering system used to identify the density of each filter also functions as a rough guide to exposure increases needed when they are used.

The numbering system used for these filters is logarithmic, which in this case means that each 0.3 increase in density is equivalent to approximately one f/stop increase in required exposure. This is a rough exposure guide and should be used only when a more accurate guide, such as the accompanying table of ND filters, is not available. For a rough guide to the effects of ND filters in combination, add the numbers to get the new density value, and then divide by 0.3 to find the required

NEUTRAL DENSITY FILTER SPECIFICATIONS

TIFFEN Type	Percent Light Transmission	Increase in f/stops
ND .1	80	$\frac{1}{2}$
ND .2	63	$\frac{3}{4}$
ND .3	50	1
ND .4	40	$1\text{-}\frac{1}{4}$
ND .5	32	$1\text{-}\frac{3}{4}$
ND .6	25	2
ND .7	20	$2\text{-}\frac{1}{4}$
ND .8	16	$2\text{-}\frac{3}{4}$
ND .9	13	3
ND 1.0	10	$3\text{-}\frac{1}{4}$
ND 1.2	6.3	$3\text{-}\frac{3}{4}$
ND 1.5	3.2	$4\text{-}\frac{1}{4}$
ND 2.0	1.0	$6\text{-}\frac{2}{3}$
ND 3.0	0.10	10
ND 4.0	0.001	$13\text{-}\frac{1}{3}$

exposure increase in f/stops. For a more accurate guide, add the increase in f/stops shown in the accompanying chart for each filter in the combination.

When focusing with a single-lens reflex camera, an ND filter may make accurate focusing difficult because of the diminished light entering the lens. If so, focus first through a similar number of light colored filters, to correct for any focus shift caused by filters, and then remove the unwanted filters and attach the ND filters to make your exposure. If you can not read the exposure with a through-the-lens metering camera, then take an exposure reading without filters, and calculate the correct exposure using the filter factor.

ND Filter Applications

There are four principal applications of ND filters. First, they can be used to reduce required exposure in extremely bright lighting conditions when the camera lens will not stop down far enough to prevent overexposure with fast film. This most frequently occurs with motion pic-

4-2a. No filter. Overexposure with fast film produces a washed-out image that lacks detail.

4-2a & b. One of the most frequent uses of a neutral density filter is to prevent overexposure when fast films are used with cameras that do not permit extensive adjustments for exposure. The ND 0.3, 0.6, and 0.9 are most often chosen for this purpose. Neutral density filters can also be used to prevent overexposure when flash is used close up.

4-2b. Use of a Tiffen ND 0.6 produced correct exposure without camera adjustments.

ture cameras that provide only one shutter speed at standard filming speed.

Second, ND filters can be used in motion picture work to control exposure under a variety of lighting conditions while shooting at one preselected aperture. This is occasionally done because at wide apertures some lenses produce a slightly soft-focus effect that is flattering to older actresses. When a diffusion filter is used, maintaining a single aperture and controlling exposure through ND filters allows you to keep the same degree of diffusion from scene to scene; changing the aperture would change the diffuse effect.

Third, these filters permit selective focusing over a wider range of f/stops than would normally be possible in bright light; and fourth, they permit an extended range of blurred motion effects. Both selective focusing and blurred motion are discussed below in detail.

Selective focusing: The area of apparently sharp focus that extends in front of and behind the point to which the lens is focused is called the *depth of field.* This area of sharp focus can be controlled by varying the aperture, small f/stops such as f/16 providing greater depth of field than wide f/stops such as f/2.8. Neutral density filters allow you to use wider f/stops when you have fast film in the camera and the light is bright. For example, let's say you are photographing outdoors with Tri-X

(ASA 400) and you have a nearby subject with a cluttered background. A normal exposure might be f/16 at 1/250 sec. But this small f/stop would also keep the background in focus. If your camera has a maximum shutter speed of 1/1000 sec., this would still require f/8, which provides considerable depth of field. To eliminate the background and render it as a blur, f/2.8 would be required. At 1/1000 sec., using an ND 0.9 filter over the lens would require you to open up 3 f/stops, to the desired f/2.8.

Selective focusing technique can eliminate unwanted backgrounds or help create mood by blurring foreground objects. It works best with moderate and long telephoto lenses, and with normal lenses. Although it can be used with wide-angle lenses, their relatively great depth of field, even at large apertures, makes the technique useful only with extremely close subjects.

Blurred motion: Subjects are blurred when the points that make up the subject image on the film become displaced, or elongated, so that they no longer appear sharp. This occurs when either the camera or the subject moves while the exposure is being made. When done inadvertently through camera shake, the result is usually an unacceptable picture. But blur can also be controlled to produce excellent pictorial results.

ND FILTER SELECTION FOR SELECTIVE FOCUS

1) If desired aperture for selective focus is . . .					
f/5.6	f/4	f/2.8	f/2	f/1.4	
2) but this aperture is needed,	3) then use Tiffen ND filter:				
f/8	ND .3	ND .6	ND .9	ND 1.2	ND 1.5
f/11	ND .6	ND .9	ND 1.2	ND 1.5	ND 1.8
f/16	ND .9	ND 1.2	ND 1.5	ND 1.8	ND 2.1
f/22	ND 1.2	ND 1.5	ND 1.8	ND 2.1	
f/32	ND 1.5	ND 1.8	ND 2.1		

A moving subject will be blurred when the camera is held steady if a sufficiently slow shutter speed is used. If close to the camera, arms or legs of a quickly moving subject will blur at 1/125 sec. and 1/500 sec. may not be fast enough to stop the wheels of a racing car moving across the field of view. Using 1/30 sec. will cause extreme blur of carnival rides, and 1/60 sec. will give a realistic look to splashing water. With fast film in bright light, blur that enhances realism can sometimes be achieved only by using ND filters, particularly with lenses that have a minimum aperture of $f/16$ or $f/22$.

With ND filters you can also achieve both selective focus and blur by reducing both the $f/$stop and shutter speed required for correct exposure.

A second technique for blur is called panning. With this method, the photographer swings the camera with the subject so that a moving subject maintains the same place in the viewfinder. The result when correctly performed is a sharp subject against a blurred background.

SPECIAL-EFFECT FILTERS

Diffusion Filters

Sometimes referred to as "soft focus" filters, diffusing discs contain concentric circles inscribed on the glass. This produces overlapping regions of sharpness and unsharpness similar to spherical aberration, which is present in old-fashioned portrait lenses. The image produced is not blurred, as it would be with camera movement, nor does it look out of focus; rather it combines two images, one sharp, the other slightly unsharp. As a result, fine lines such as wrinkles in the face tend to disappear, backlight takes on a luminous glow, and bright areas of the subject tend to spread into the shadows.

These effects are particularly desirable in portraiture. They are pleasing and produce a romantic or idealized version of the subject, free from marks of age or stress. They are particularly useful in candid portraiture where retouching is seldom practical.

The degree of diffusion is variable, de-

ND FILTER SELECTION FOR CORRECT EXPOSURE
WITH SLOW SHUTTER SPEEDS AND FAST FILMS

2) and this is stop for correct exposure,	1) If smallest marked stop is . . .		
	f/16	f/22	f/32
	3) then use ND filter:		
f/22	ND .3	none	none (use f/22)
f/32	ND .6	ND .3	none
f/45	ND .9	ND .6	ND .3
f/64	ND 1.2	ND .9	ND .6
f/90	ND 1.5	ND 1.2	ND .9
f/128	ND 1.8	ND 1.5	ND 1.2
f/180	ND 2.1	ND 1.8	ND 1.5
f/256	ND 2.4	ND 2.1	ND 1.8

pending on the filter grade used. Tiffen Diffusion Filters are supplied in grades 1 through 5, giving a complete range of diffusion effects from a slight overall image softening to complete diffusion with flaring highlights, misty appearance, and the blending of colors. The amount of diffusion produced also varies with the aperture selected, small apertures lessening the effect, wide apertures yielding maximum diffusion. When a particular aperture is desired, shutter speed or ND filters can be used to control exposure.

This group of filters can be used in combination with either contrast filters or filters for color to produce innumerable creative variations. When used over an enlarger lens during print making, they spread shadows into highlight areas, diffuse fine detail, and produce slightly dark effects that may add a feeling of mystery with some subjects.

Low-Contrast Filters

The combination of modern high-quality lenses and today's color films produce brilliant, well-saturated colors with clearly defined separation between adjacent color areas. Although this effect is usually desirable, there are many situations in which desaturated, muted colors may be preferred. These low-contrast color effects may be achieved by using Tiffen Low-Contrast Filters, which are available in series sizes in a five-step range from 1 through 5. They may also be used in combination for increased effect. No exposure compensation is required when using the No. 1, 2, or 3 filters. In low-contrast lighting a $\frac{1}{3}$ - $\frac{1}{2}$ f/stop increase may be required for portraits.

Low-contrast filters produce misty, dream-like effects in which adjacent areas of color seem to blend, and light seems to be diffused throughout the picture area. They work well with either color-slide or color-print films and are useful for portraiture and for advertising photography when a romantic mood is required.

The subtle muting of color is an effective mood enhancer in motion-picture photography and commercial shooting for television.

Fog-Effect Filters

Tiffen Fog-Effect Filters, which are supplied in densities 1 through 5, create the effect of a misty atmospheric haze, or fog. They can be used effectively with all types of lenses and at any f/stop. They are available in series sizes, direct screw-in, square, and rectangular sizes. No filter factor is needed for a grey, low-contrast effect. For misty atmosphere fog with little contrast loss, open up $\frac{1}{3}$ f/stop for the No. 1 and No. 2, $\frac{1}{2}$ f/stop for No. 3 or No. 4, and 1 f/stop for the No. 5.

They may be used singly or in combination for a wide range of effects. The greater the density, the greater the effect, as can be seen in the accompanying photographs.

4-3a. No filter.

4-3b. Tiffen No. 3 diffusion filter.

4-3c. Tiffen No. 5 diffusion filter.

Fog filters may be used with either black-and-white or color films and do not produce color casts. They are frequently selected to produce romantic or dream-like effects in motion-picture and television camera work. They can also be used for similar effects in home-movie making and in still pictorial photography.

When artificial lights, such as household lamps or street lights, are included within the field of view, the light becomes a glowing ball and backlighted figures seem to be surrounded by a glowing aura.

Sky-Control Filters

Tiffen Sky-Control Filters are designed to eliminate the problem of overexposure and washing out of sky and clouds in outdoor scenes without altering color quality or changing tonal values. In color photography, they provide the only effective means of overall sky darkening. In

4-3a, b & c. A diffusion filter used on the camera blends highlights into neighboring shadows, softens lines, and smooths wrinkles. A wide range of effects are possible, depending on the number of the diffusion filter and the f/stop used.
Camera: Nikon FTN with 85mm lens. Film: Kodak Plus-X. Photos by Kathleen Benveniste.

4-4a. No filter.

4-4a & b. The sky control filter permits darkening of even an overcast sky by one-three *f*/stops, depending on the filter selected. A slight exposure increase may be required to compensate for light absorbed by the neutral density portion of the filter. Varying the distance between the front lens element and the filter will alter the effect; the optimum separation usually being about one half the focal length of the lens. This can be achieved by adding one or more retaining rings to the adapter before putting on the filter. Camera: GAF L-CS with 35 mm lens. Film: GAF 125.

4-4b. Tiffen 0.9 Sky Control filter.

black-and-white work, they provide an alternative to the use of contrast filters and are the only means of darkening overcast sky.

Sky-control filters are one-half neutral density and one-half clear glass. The neutral density portion has a feathered edge to give a pleasing blend of sky and foreground in the final picture. The filters are supplied in densities 0.3, 0.6, and 0.9 and are available in series, direct screw-in, and square sizes.

Since the purpose in using these filters is to darken the sky by one to three stops, no filter compensation is required. Exposure readings should be made of the subject only (without the sky), and the camera adjusted accordingly. For best results, do not use through-the-lens metering with this filter in place, since this reading would partially negate the effect of the neutral density and could overexpose the lower portion of the picture. If you are using a through-the-lens metering camera, make your exposure reading without the filter, adjust the camera manually to the required setting, and then put on the filter to make the exposure.

To use a sky-control filter, frame your scene so that the neutral density portion reaches just to the sky line. Keep your subject within the lower, clear portion of the filter, since any vertical object extending from the clear into the neutral density portion of the filter will be divided into dark and light portions. Keeping the subject in the clear portion is most easily achieved when you use high camera positions in which the subject is photographed from a slightly downward angle.

Indoors, the sky-control filter can be used to subdue artificial lights that are included within the field of view of the lens by turning the filter so that the light is in the neutral density portion and your subject is in the clear portion. By rotating the filter and experimenting with various camera positions, you will find positions in which

the line between clear and dark portions of the filter is not disturbing. If you are using an automatic camera with through-the-lens metering, reduction in the intensity of lights included within the field of view of the lens should result in better subject exposure.

Sky-control filters are best used with single-lens reflex cameras or through-the-lens reflex movie cameras. With rangefinder and separate-viewfinder cameras, the filter effect can only be estimated.

Star-Effect Filters

Tiffen Star-Effect Filters are engraved with cross-hatched lines that produce four-point, six-point, or eight-point needles of light that radiate from bright highlights and point sources of light such as lamps or candles. Technically the effect is the result of a diffraction produced by the cross-hatching.

These filters are supplied in series, direct screw-in, square, and rectangular sizes. Each filter is also available in several grid sizes. The four-point star filter is available in 1mm, 2mm, and 3mm grids; the six-point star in 2mm, 3mm, and 4mm grids; the eight-point star in 2mm, 3mm, and 4mm grids. The size of the grid determines the overall diffusion, with the smaller 1mm and 2mm grids producing more overall diffusion of the image and less brilliant, subtle, star effects. For brilliant stars with minimum diffusion, choose the larger grid sizes; for glittering, romantic effects, select the smaller grid sizes.

These filters can be used with all lenses, and are effective in still, motion-picture, and television camera work. For best results, use apertures in the $f/4$ to $f/8$ range: Effects diminish at smaller apertures and wide apertures may give a slightly out-of-focus appearance to the scene.

The closer you are to a point source of light, such as a street light or candle, the more brilliant and larger the star. The brilliance and intensity of highlights, such

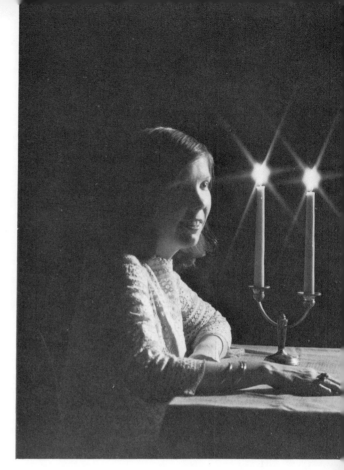

4-5a (above left). Tiffen 4 point star filter (3mm grid).

4-5b (above). Tiffen 6 point star filter (3mm grid).

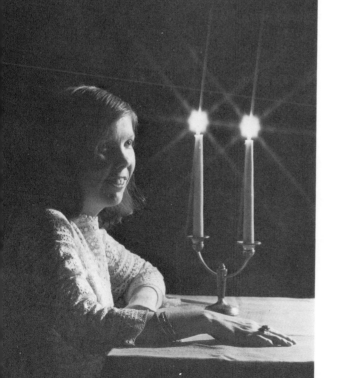

4-5a, b & c. Star effects are most pronounced when a point source of light imaged against a dark background and considerable distance exists between camera and light source. In this series, black paper was used as a background and a 135mm lens gave optimum camera-to-subject distance. Additional fill-in light for the subject's face was provided by a 250-watt spotlight outside the field of view of the lens. Camera: GAF L-CS. Film: GAF 125.

4-5c. Tiffen 8 point star filter (3mm grid).

4-6a. Using a 135mm lens with a Tiffen +¹/₂ Split-Field Lens makes it possible to combine a close-up portrait with an enlarged image of a distant piece of sculpture.

4-6a & b. A split-field lens with a fractional diopter is particularly useful when water, traffic, or some other obstacle prevents your getting a foreground subject close to a background object. By using a telephoto lens and a split-field lens, a distant sign, piece of sculpture, or building can be brought into sharp focus with a smaller subject close to the camera.

4-6b. Using the 135mm lens without a split-field attachment produces a blurred foreground image due to limitations of depth of field.

as those produced by the sequined clothing favored by some entertainers or by moving water, will depend on the intensity of the light source and the angle at which the light is reflected into the lens. By changing camera angle, different effects can be created.

To change the orientation of the star points, rotate the filter. If you are using a through-the-lens viewing system, stop down the lens to the aperture that will be used to make the exposure in order to see the exact effects achieved.

Star filters are frequently used in advertising and pictorial work to add sparkle in marine scenes and in product shots of glassware, automobiles, jewelry, and other items. They are often used when photographing concerts because they provide a dynamic visual interpretation of the entertainment. By placing a small chip of Mylar or some other reflective substance at strategic points on a subject, the position of star highlights can be controlled. For example, a chip of Mylar stuck to a tooth can create occasional star-bursts of light when the subject smiles.

Split-Field Lenses

Tiffen Split-Field Lenses are half close-up lens and half clear (without glass). This results in two fields of focus, one near, the other far. This can be used to create extreme depth of field or for combining small, close subjects with normal-size subjects in the middle distance or background.

The creative possibilities with split-field lenses are endless. For example, you can combine a full-figure shot of a model with a tiny sea shell in such a way that the model appears to be coming out of the shell, or running into it. With a normal or moderate telephoto lens and one of the fractional diopter split-field lenses, you can make a head-and-shoulders portrait in

which the background, right to infinity, is in sharp focus.

Tiffen Split-Field Lenses are supplied in +1/4, +1/2, +3/4, +1, +2, +3, and +4 diopter strengths in screw-in and series sizes. The numbers refer to the close-up power of the lens and are identical with the close-up lenses described in Chapter 5.

To focus and compose using a split-field lens and a single-lens reflex camera, focus first on the middle or distant background subject using the focusing mount on the lens. Next, bring the close-up subject into focus by moving the entire camera or lens toward or away from the subject as required. Recheck background focus, and adjust as necessary, then make your exposure. For best results, use the smallest f/stop possible, preferably $f/11$ or $f/16$. This procedure is standard when using any close-up attachment.

The dividing line between the two halves of the attachment should be carefully placed to avoid having it appear as an out-of-focus line in the picture. When it coincides with a very dark or light area in which there is little or no detail, the line usually disappears. Alternatively, you could turn the filter until the split falls on some naturally diffuse portion of the subject, such as the outside edge of the hair. Try to keep the near subject well within the close-up portion of the lens. Watch for strong lights within the field of view, because they may be refracted along the split and appear as double straight lines or imaged as half doughnut shapes.

Split-field lenses are most easily used with cameras that feature through-the-lens viewing. To use these lenses with other types of cameras, use the chart on page 67 in Chapter 5 to find the correct close-up-lens to subject distance. The location of the split in the final picture will have to be estimated.

4-7a. Tiffen +3 split-field lens. Note how the model is reflected in the base of the bottle.

4-7b. Without the split-field lens, the bottle is a blur, although its size remains constant in the frame because there is no change in camera-to-subject distance.

4-7a, b & c. In this series a Tiffen +3 split-field lens was used in front of a 50mm lens to combine a small bottle with a model in the background. Camera: Nikon FTN. Film: Kodak Plus-X. All photos made at f/8. Photos by Kathleen Benveniste.

4-7c. To set up the shot, the bottle was placed on a table draped with black cloth. The model then rested her arms on the table. Black seamless paper was used as a background.

5

Close-up
Photography

The Tiffen close-up lenses detailed here are inexpensive lenses that are mounted in front of your camera lens to shorten its effective focal length. With these lenses you can get close to your subject and still get sharp pictures. They are supplied in various powers to give you an extended focusing range that can reach down to just a few inches.

The numerical designations of Tiffen close-up lenses refer to plus (+) diopters and range from +1/4 to +10. The greater the diopter power, the closer the focusing range made possible. Close-up lenses are available in either direct, screw-in mounts or in series sizes for use with a Tiffen adapter ring.

Tiffen close-up lenses are made of ground and polished optical glass so that they can be used with confidence as part of a high-quality lens system.

Applications of Close-Up Lenses

The supplementary close-up lens can be used for everything from tighter composition with telephoto lenses to extreme close-ups of tiny subjects with normal or moderate wide-angle lenses.

The fractional lenses (+1/4, +1/2, +3/4) are generally used with telephotos from 135mm to 300mm in the 35mm camera

format or their equivalent in other formats. These long lenses are usually unable to focus closer than 8 or 15 feet. With the fractional lenses, you can cut your close-focusing distance by half or more and retain the advantages of good perspective and selective focus associated with telephoto lenses. When photographing in industrial environments, they allow you to get close-ups of hands, parts of machinery, and small operations, and yet keep you far enough away so that you do not interfere with the operation.

Any normal lens equipped with a +1 lens becomes a portrait camera capable of top-quality results. The professional touch appears because extraneous background is eliminated and you can fill the entire image area with bust or head only. This application is so popular that the +1 close-up lens is often referred to as a *portrait lens.*

When you use the more powerful supplementary lenses, it then becomes possible to photograph very small areas ranging from the size of a sheet of typewriter paper down to small paper clips. Close-up lenses can also be used with cameras having double-extension bellows or extension rings to achieve magnified images larger than the original subjects.

New, exciting, and different movies can be made by placing Tiffen close-up lenses

5-1a. No close-up lens; 55mm lens at closest focusing distance.

5-1b. Tiffen +1 close-up lens with 55mm lens.

5-1c. Tiffen +1 close-up lens with 135mm lens.

5-1d. Tiffen +3 close-up lens with 55mm lens.

5-1e. Tiffen +3 close-up lens with 135mm lens.

5-1f. Tiffen +10 close-up lens with 55mm lens.

5-1a-f. The size of an image produced by a close-up lens depends on both the diopter of the lens and the focal length of the camera lens. Depth of field depends on the image size on the negative, not on the strength of the close-up lens. This series of photos shows close-up views made with a 55mm normal lens and a 135mm moderate telephoto lens. The statuette is 17 inches high. Camera: GAF L-CS. Film: GAF 125.

on your zoom movie camera. Even relatively still objects shot close-up can be made to "move" by zooming in and out on them. For instance, let us imagine you are making a shot of a flower. At the beginning of the action the flower appears small and insignificant on the screen. By operating the zoom lever on your camera so that your lens focal length is increased gradually, the blossom will seem to move closer and closer until only a small portion of it fills the frame.

The same technique can be employed in shooting portraits that first include the entire head, then gradually narrow down to a portion of the face, and finally concentrate on expression.

Once you've placed a close-up lens on your zoom lens and established the proper working distance, you need not move either camera or tripod in order to change image or field size. It is also unnecessary to make any changes in focusing. Your image will remain in focus throughout the entire range of the zoom lens. Exposure too will remain constant.

Another bonus you get using a zoom lens for close-up work is that color rendition remains constant during the entire sequence. This might not be the case if you had to change from one lens to another to vary the image size. Tiffen close-up lenses are made from the finest clear white optical glass and do not alter color renditions.

Diopter Close-up	+1	+2	+3	+4	+5
Subj.to-CU dist. (in.)	39¹/₂	19³/₄	13	9³/₄	8
8mm	16-¹/₈ × 21	8-¹/¹₁₆ × 10-¹/₂	5-³/₈ × 7	4-¹/₁₆ × 5-¹/₄	3-¹/₄ × 4-³/₁₆
9mm	14-³/₈ × 18-¹¹/₁₆	7-³/₁₆ × 9-⁵/₁₆	4-³/₄ × 6-¹/₄	3-⁹/₁₆ × 4-¹¹/₁₆	2-⁷/₈ × 3-³/₄
10mm	12-¹⁵/₁₆ × 16-¹³/₁₆	6-⁷/₁₆ × 8-⁷/₁₆	4-⁵/₁₆ × 5-⁵/₈	3-¹/₄ × 4-³/₁₆	2-⁹/₁₆ × 3-³/₈
24mm	5-³/₈ × 7	2-¹¹/₁₆ × 3-¹/₂	1-¹³/₁₆ × 2-⁵/₁₆	1-⁵/₁₆ × 1-³/₄	1-¹/₁₆ × 1-⁷/₁₆
27mm	4-³/₄ × 6-¹/₄	2-³/₈ × 3-¹/₈	1-⁹/₁₆ × 2-¹/₁₆	1-³/₁₆ × 1-⁹/₁₆	¹⁵/₁₆ × 1-¹/₄
30mm	4-⁵/₁₆ × 5-⁵/₈	2-¹/₈ × 2-¹³/₁₆	1-⁷/₁₆ × 1-⁷/₈	1-¹¹/₁₆ × 1-³/₈	⁷/₈ × 1-¹/₈
40mm	3-¹/₄ × 4-³/₁₆	1-⁵/₈ × 2-¹/₈	1-¹/₁₆ × 1-³/₈	¹³/₁₆ × 1-¹/₁₆	⁵/₈ × ¹³/₁₆

Diopter Close-up	+6	+7	+8	+9	+10
Subj.to-CU dist. (in.)	6¹/₂	5¹/₂	5	4¹/₂	4
8mm	2-¹¹/₁₆ × 3-¹/₂	2-⁵/₁₆ × 3	2 2 × 2-⁵/₈	1-¹³/₁₆ × 2-⁵/₁₆	1-⁵/₈ × 2-¹/₈
9mm	2-³/₈ × 3-¹/₈	2-¹/₁₆ × 2-¹¹/₁₆	1-¹³/₁₆ × 2-⁵/₁₆	1-⁹/₁₆ × 2-¹/₁₆	1-⁷/₁₆ × 1-⁷/₈
10mm	2-³/₁₆ × 2-¹³/₁₆	1-⁷/₈ × 2-³/₈	1-⁵/₈ × 2-¹/₈	1-⁷/₁₆ × 1-⁷/₈	1-⁵/₁₆ × 1-¹¹/₁₆
24mm	⁷/₈ × 1-³/₁₆	³/₄ × 1	¹¹/₁₆ × ⁷/₈	⁵/₈ × ³/₄	⁹/₁₆ × ¹¹/₁₆
27mm	¹³/₁₆ × 1-¹/₁₆	¹¹/₁₆ × ⁷/₈	⁹/₁₆ × ³/₄	¹/₂ × ¹¹/₁₆	⁷/₁₆ × ⁵/₈
30mm	³/₄ × ¹⁵/₁₆	⁵/₈ × ¹³/₁₆	¹/₂ × ¹¹/₁₆	⁷/₁₆ × ⁵/₉	⁷/₁₆ × ⁹/₁₆
40mm	¹/₂ × ¹¹/₁₆	⁷/₁₆ × ⁵/₈	³/₈ × ¹/₂	³/₈ × ⁷/₁₆	⁵/₁₆ × ⁷/₁₆

Using Close-up Lenses

With zoom cameras having through-the-lens viewfinder or ground-glass focusing, focus and frame your subject as you would for regular picture-taking. With these cameras, all lenses from +1 to +10 may easily be used.

For movie cameras that do not have through-the-lens focusing, the working distance from the lens to the subject must be measured with ruler or tape measure, and the area seen by the lens estimated. Close-up lenses stronger than +3 should not be used with these cameras because stronger close-up lenses produce a very shallow depth of field and camera placement has to be extremely accurate.

A Tiffen close-up lens fits the camera just like a filter, but being a lens, it is directional and must be positioned to face the proper way. All Tiffen close-up lenses have an engraved arrow on the metal rim which must point *toward the subject.*

Tiffen close-up lenses require no change in exposure. They may be used in combination, the resultant power being the sum of the two individual powers. When using close-up lenses in combination, always position the strongest one closest to the camera lens. Close-up lenses may also be used together with any filter. Place the close-up lens next to the camera lens and the filter on the outside. Adjust exposure for the filter in the usual way.

For maximum sharpness, stop down to $f/11$ or more and use a fast shutter speed to minimize camera movement and vibrations. A fast film permits the use of higher shutter speeds and smaller apertures, but also results in a grainier image than slower films. Through experience, you can learn the combinations of film, f/stop, and shutter speed that seem to produce the best results with your favorite subjects.

Best results are obtained in close-up photography by using a tripod or other steady support. Hand-held photographs using supplementary lenses generally require speeds of at least 1/125 sec. and often 1/250 sec. to eliminate camera movement with normal lenses. Using telephoto lenses requires even higher shutter speeds.

TIFFEN CLOSE-UP LENSES WITH MOVIE CAMERAS

Camera Lens	Camera Lens Focus Scale Setting in Feet	Tiffen + 1 Close-up Lens		Tiffen + 2 Close-up Lens		Tiffen + 3 Close-up Lens	
		Inches from Subject to Lens	Area Seen By Lens (inches)	Inches from Subject to Lens	Area Seen By Lens (inches)	Inches from Subject to Lens	Area Seen By Lens (inches)
25 mm	Inf.	—	—	19-$\frac{1}{2}$	5-$\frac{5}{8}$ X 7-$\frac{1}{2}$	13	3-$\frac{3}{4}$ X 5
	50	—	—	19-$\frac{1}{8}$	5-$\frac{3}{8}$ X 7-$\frac{1}{4}$	12-$\frac{7}{8}$	3-$\frac{5}{8}$ X 4-$\frac{7}{8}$
	25	—	—	18-$\frac{1}{2}$	5-$\frac{1}{4}$ X 7	12-$\frac{1}{2}$	3-$\frac{1}{2}$ X 4-$\frac{3}{4}$
	15	—	—	17-$\frac{3}{4}$	5 X 6-$\frac{3}{4}$	12-$\frac{1}{4}$	3-$\frac{1}{2}$ X 4-$\frac{5}{8}$
	10	—	—	16-$\frac{7}{8}$	4-$\frac{3}{4}$ X 6-$\frac{3}{8}$	11-$\frac{7}{8}$	3-$\frac{3}{4}$ X 4-$\frac{1}{2}$
	8	—	—	16-$\frac{3}{8}$	4-$\frac{5}{8}$ X 6-$\frac{1}{4}$	11-$\frac{1}{2}$	3-$\frac{1}{4}$ X 4-$\frac{3}{8}$
	6	—	—	15-$\frac{1}{2}$	4-$\frac{3}{8}$ X 5-$\frac{7}{8}$	11-$\frac{1}{8}$	3-$\frac{1}{8}$ X 4-$\frac{1}{4}$
	4	21-$\frac{3}{8}$	6-$\frac{1}{8}$ X 8-$\frac{1}{8}$	14	4 X 5-$\frac{1}{4}$	10-$\frac{3}{8}$	2-$\frac{7}{8}$ X 3-$\frac{7}{8}$
	3	18-$\frac{1}{2}$	5-$\frac{1}{4}$ X 7	12-$\frac{5}{8}$	3-$\frac{1}{2}$ X 4-$\frac{3}{4}$	9-$\frac{1}{2}$	2-$\frac{3}{4}$ X 3-$\frac{5}{8}$
	2	14-$\frac{3}{8}$	4-$\frac{1}{8}$ X 5-$\frac{1}{2}$	10-$\frac{1}{2}$	3 X 4	8-$\frac{1}{4}$	2-$\frac{3}{8}$ X 3-$\frac{1}{4}$
13 mm	Inf.	—	—	19-$\frac{1}{2}$	5 X 6-$\frac{3}{4}$	13	3-$\frac{3}{8}$ X 4-$\frac{1}{2}$
	50	—	—	19-$\frac{1}{8}$	4-$\frac{7}{8}$ X 6-$\frac{1}{2}$	12-$\frac{7}{8}$	3-$\frac{3}{8}$ X 4-$\frac{3}{8}$
	25	—	—	18-$\frac{1}{2}$	4-$\frac{3}{4}$ X 6-$\frac{3}{8}$	12-$\frac{1}{2}$	3-$\frac{1}{4}$ X 4-$\frac{3}{8}$
	15	—	—	17-$\frac{3}{4}$	4-$\frac{5}{8}$ X 6-$\frac{1}{8}$	12-$\frac{1}{4}$	3-$\frac{1}{4}$ X 4-$\frac{1}{4}$
	10	—	—	16-$\frac{7}{8}$	4-$\frac{3}{8}$ X 5-$\frac{7}{8}$	11-$\frac{7}{8}$	3-$\frac{1}{8}$ X 4-$\frac{1}{8}$
	8	—	—	16-$\frac{3}{8}$	4-$\frac{1}{4}$ X 5-$\frac{5}{8}$	11-$\frac{1}{2}$	3 X 4
	6	—	—	15-$\frac{1}{2}$	4 X 5-$\frac{3}{8}$	11-$\frac{1}{8}$	2-$\frac{7}{8}$ X 3-$\frac{7}{8}$
	4	21-$\frac{3}{8}$	5-$\frac{5}{8}$ X 7-$\frac{1}{2}$	14	3-$\frac{5}{8}$ X 4-$\frac{7}{8}$	10-$\frac{3}{8}$	2-$\frac{5}{8}$ X 3-$\frac{1}{2}$
	3	18-$\frac{1}{2}$	4-$\frac{7}{8}$ X 6-$\frac{1}{4}$	12-$\frac{5}{8}$	3-$\frac{1}{4}$ X 4-$\frac{3}{8}$	9-$\frac{1}{2}$	2-$\frac{1}{2}$ X 3-$\frac{3}{8}$
	2	14-$\frac{3}{8}$	3-$\frac{7}{8}$ X 5-$\frac{1}{8}$	10-$\frac{1}{2}$	2-$\frac{3}{4}$ X 3-$\frac{3}{4}$	8-$\frac{1}{4}$	2-$\frac{1}{4}$ X 3

The larger the image in the frame, the smaller the depth of field (depth of the apparently sharp area); with the strongest close-up lenses, depth of field may become extremely shallow, sometimes amounting to no more than a fraction of an inch; hence, maximum steadiness and careful focusing are prerequisites for good results.

For best results it is desirable that you use the single close-up lens required for each assignment. However, where a large number of different magnifications are needed, carrying a whole set of ten lenses may prove to be inconvenient. Varying strengths from +1 to +10 can be obtained by combining two of the lenses at the same time, using Tiffen retaining rings.

Focusing. Once the close-up lens is in place, the close-focusing range of the lens will be increased, but the lens will no longer focus on distant subjects. With moderately powerful close-up lenses ranging up to +3 diopters, the usual method with single-lens reflex cameras is to position yourself so that the camera-to-subject distance is within the focusing range of the supplementary lens and then to use the camera's focusing provisions for fine focus. With normal or wide-angle lenses and strong close-up lenses, it may be easier to focus the lens at infinity and then move the camera back and forth for fine focus.

With rangefinder cameras, or those having a simple viewfinder, it is necessary to measure the distance between the subject and the front of the supplementary lens. The distances required with various camera and close-up lens combinations are given in the accompanying chart.

Because plain viewfinder and rangefinder cameras are not designed to be used at such close focusing distances, the following focusing procedure should be used: Align the camera so that the back of the camera is roughly parallel with the important part of your subject. The subject should be centered in front of the lens (not the viewfinder). Set the focus indicator on the

camera to one of the distances shown on the accompanying chart and arrange your camera-to-subject distance accordingly. Make your measurements from the front of the close-up lens.

To use a twin-lens reflex, attach one close-up lens to the taking lens and an identical one to the viewing lens. Focusing and composition are then handled in the usual way except that the taking lens must be shifted to the exact position of the viewing lens when shooting. Alternatively, with $2\frac{1}{4}$" \times $2\frac{1}{4}$" twin-lens reflex cameras, you can ignore the tope 3mm of the viewing screen with a +1 lens, the top 6mm with a +2 lens, and the top 9mm with a +3 lens.

The area covered with a standard camera lens plus close-up lens can also be found in the accompanying chart. When close-up lenses are used with long-focus or telephoto lenses, the working distance will be the same as that achieved with a normal lens, but the image size will be larger in direct proportion to the length of the telephoto lens. Thus, if an object photographed with a 50mm lens and a +2 close-up lens from a working distance of 20 inches gives an image diameter of 1/2 inch on the film, then with a 100mm lens, the working distance will still be 20 inches but the same subject area will now have a diameter of 1 inch on the film; with a 200mm lens, it will be 2 inches; and so on. For best results with telephoto lenses, use the smallest possible f/stop and close-up lenses of +5 or less.

Close-up lens selection. To select a close-up lens, look at the accompanying chart and note the area covered at maximum and minimum focusing distances with the various close-up lenses. These figures are given for the normal lens used with various formats. For a lens of twice the normal focal length, divide the dimensions by two. This method gives you a rough guide to the effects you will get.

For the mathematically minded, the diopter scale provides a method of calculating effects in terms of focal length. To obtain a focal length in millimeters using diopters, just divide the number of diopters into 1000. Thus, the focal length of a +4 lens is $1000 \div 4 = 250$mm.

To find the combined focal length of your camera lens and a close-up lens, first find the diopter power of your camera lens by dividing its focal length, in millimeters, into 1000. Then add the result to the diopters of the supplementary lens. Divide the total number of diopters (camera lens plus close-up lenses) into 1000 to find the new focal length in millimeters. For example, to find the combined focal length of a 50mm camera lens with a 3+ and a +2 close-up lens combination, you would perform the following calculations:

Diopters of 50mm lens: $1000 \div 50 = 20$
Total diopters of all lenses: $20 + 3 + 2 = 25$
Combined focal length: $1000 \div 25 = 40$mm

If you already know what focal length you want, you can calculate the combination of close-up lenses that will be required. For example, to change a 50mm lens into a 35mm lens, the required supplementary lenses would be calculated as follows:

Diopters of 50mm lens: $1000 \div 50 = 20$
Diopters of 35mm lens: $1000 \div 35 = 28.6$
Diopters of supplementary close-up
lenses required: $28.6 - 20 = 8.6$
Rounding off 8.6 to 9 gives the required power, which could be achieved
by combining a +4 with a +5 close-up lens.

When the 50mm lens is converted to the equivalent of a 35mm lens, the effect is that of a 35mm lens with an extension tube between the lens and the camera body, which permits close focusing. In this case, the mount of the 50mm lens acts as an extension tube. Since the 50mm lens has f/stops that already take into account the

TIFFEN CLOSE-UP LENSES WITH STILL CAMERAS

Tiffen Close-up Lens (diopters)	Footage Setting on Camera	Inches from Subject to Close-Up Lens	Area Seen by Lens (inches)*				
			45mm Lens 24 x 36mm Negative	50mm Lens 24 x 36mm Negative	50mm Lens 28 x 40mm Negative	75mm Lens 2-1/4 x 2-1/4 in. Negative	100mm Lens 2-1/4 x 3-1/4 in. Negative
+1	Inf.	38-3/4	20-1/2 X 31	18-5/8 X 28	21-7/8 X 31-1/4	30 X 30	22-1/8 X 32
	50	37		17-3/4 X 26-5/8	20-1/2 X 29-1/4	28 X 28	21 X 30-1/4
	25	34-3/4		16-5/8 X 25	19-1/4 X 27-1/2	26-1/8 X 26-1/8	19-5/8 X 28-3/8
	"FIXED"	33-3/4		16 X 24	18-3/4 X 26-3/4	25-1/2 X 25-1/2	19 X 27-1/2
	15	32-3/8		15-3/8 X 23	17-7/8 X 25-1/2	24-1/4 X 24-1/4	18-3/4 X 27-1/8
	10	29-5/8	15-1/2 X 23	14 X 21	16-1/8 X 23-1/8	22 X 22	16-3/8 X 23-5/8
	8	27-7/8		13-1/8 X 19-3/4	15-1/8 X 21-5/8	20-1/2 X 20-1/2	15-1/4 X 22-1/8
	6	25-1/2		11-7/8 X 17-7/8	13-3/4 X 19-5/8	18-5/8 X 18-5/8	13-3/4 X 19-7/8
	5	23-3/4	12-1/2 X 18	11 X 16-5/8	12-3/4 X 18-1/4	17-1/8 X 17-1/8	12-3/4 X 18-3/8
	4	21-5/8		10 X 15	11-1/2 X 16-1/2	15-3/8 X 15-3/8	11-3/8 X 16-3/8
	3-1/2	20-3/8	10-1/4 X 15-1/2	9-1/4 X 14	10-3/4 X 15-3/8	14-3/8 X 14-3/8	10-1/2 X 15-1/4
+2	Inf.	19-1/2	10-1/2 X 14-7/8	9-3/8 X 14	10-7/8 X 15-1/2	14-3/4 X 14-3/4	11-1/8 X 16-1/8
	50	19-1/8		9-1/8 X 13-5/8	10-1/2 X 15-1/8	14-3/8 X 14-3/8	10-3/4 X 15-5/8
	25	18-1/2		8-7/8 X 13-1/4	10-1/4 X 14-5/8	13-7/8 X 13-7/8	10-3/8 X 15
	"FIXED"	18		8-5/8 X 12-7/8	10 X 14-1/4	13-1/2 X 13-1/2	10-1/8 X 14-5/8
	15	17-3/4		8-1/2 X 12-3/4	9-7/8 X 14	13-1/8 X 13-1/8	9-7/8 X 14-3/8
	10	16-7/8	8-1/2 X 12-1/4	8 X 12	9-1/4 X 13-1/4	12-1/2 X 12-1/2	9-3/8 X 14
	8	16-3/8		7-3/4 X 11-1/2	8-7/8 X 12-3/4	12 X 12	8-7/8 X 12-7/8
	6	15-1/2		7-1/4 X 10-7/8	8-3/8 X 12	11-1/4 X 11-1/4	8-3/8 X 12
	5	14-7/8	7-3/8 X 10-1/2	6-7/8 X 10-3/8	8 X 11-1/2	10-3/4 X 10-3/4	7-7/8 X 11-3/8
	4	14		6-1/2 X 9-5/8	7-1/2 X 10-3/4	10 X 10	7-1/4 X 10-1/2
	3-1/2	13-3/8	6-1/4 X 9-1/8	6-1/8 X 9-1/4	7-1/8 X 10-1/8	8-7/8 X 8-7/8	6-7/8 X 10
+3	Inf.	13	6-1/8 X 9-1/4	6-1/4 X 9-3/8	7-1/4 X 10-3/8	9-7/8 X 9-7/8	7-1/2 X 10-3/4
	50	12-7/8		6-1/8 X 9-1/4	7-1/8 X 10-1/8	9-5/8 X 9-5/8	7-1/4 X 10-1/2
	25	12-1/2		5-7/8 X 8-7/8	6-7/8 X 9-7/8	9-3/8 X 9-3/8	7-1/8 X 10-1/4
	"FIXED"	12-3/8		5-7/8 X 8-7/8	6-7/8 X 9-3/4	9-1/4 X 9-1/4	7 X 10
	15	12-1/4		5-3/4 X 8-3/4	6-3/4 X 9-5/8	9-1/8 X 9-1/8	6-7/8 X 9-7/8
	10	11-7/8	6 X 8-7/8	5-5/8 X 8-3/8	6-1/2 X 9-1/4	8-3/4 X 8-3/4	6-1/2 X 9-1/2
	8	11-1/2		5-3/8 X 8-1/8	6-1/4 X 8-7/8	8-3/8 X 8-3/8	6-3/8 X 9-1/8
	6	11-1/8		5-1/8 X 7-7/8	6 X 8-5/8	8 X 8	6 X 8-5/8
	5	10-3/4	5-1/2 X 8	4-7/8 X 7-1/2	5-3/4 X 8-1/4	7-3/4 X 7-3/4	5-3/4 X 8-1/4
	4	10-3/8		4-3/4 X 7-1/8	5-1/2 X 7-7/8	7-3/8 X 7-3/8	5-3/8 X 7-3/4
	3-1/2	10	5-1/8 X 7-1/2	4-1/2 X 6-7/8	5-1/4 X 7-1/2	7 X 7	5-1/4 X 7-1/2
+4	Inf.	9-7/8	5-1/4 X 7-1/2	4-5/8 X 7	5-1/2 X 7-3/4	7-3/8 X 7-3/8	5-5/8 X 8-1/8
	"FIXED"	9-1/2		4-1/2 X 6-5/8	5-1/8 X 7-1/2	7 X 7	5-3/8 X 7-3/4
	3-1/2	8	4 X 6	3-5/8 X 5-3/8	4-1/8 X 6	5-1/2 X 5-1/2	4-1/8 X 6
+5	Inf.	7-7/8	4 X 6	3-3/4 X 5-5/8	4-1/4 X 6-1/4	5-7/8 X 5-7/8	4-1/2 X 6-1/2
	"FIXED"	7-5/8		3-1/2 X 5-3/8	4-1/8 X 6	5-5/8 X 5-5/8	4-1/4 X 6-1/8
	3-1/2	6-1/2	3-1/4 X 4-5/8	3 X 4-3/8	3-1/2 X 4-7/8	4-1/2 X 4-1/2	3-3/8 X 4-3/4
+6	Inf.	6-1/2	3-1/4 X 4-7/8	3 X 4-5/8	3-5/8 X 5-1/8	4-7/8 X 4-7/8	3-3/4 X 5-3/8
	"FIXED"	6-3/8		3 X 4-3/8	3-3/8 X 4-7/8	4-3/4 X 4-3/4	3-5/8 X 5-1/4
	3-1/2	5-5/8	2-3/4 X 4-1/8	2-1/2 X 3-3/4	3 X 4-1/4	3-7/8 X 3-7/8	2-7/8 X 4-1/4
+8	Inf.	5-1/8	2-1/2 X 3-3/4	2-1/4 X 3-3/8			
	4	4-5/8	2-1/4 X 3-1/4	2 X 3			
+10	Inf.	4-1/4	2-1/8 X 3-1/8	1-7/8 X 2-3/4			
	4	4	1-7/8 X 2-5/8	1-5/8 X 2-1/2			

*Data is approximate. The area seen by lens depends to some extent on the separation between supplementary and camera lenses. All focal lengths given are considered average.

length of the lens barrel, an exposure increase is not required, as it would be when using a 35mm lens with extension tube.

HANDLING SELECTED SUBJECTS

Portraits

The combination of a normal lens and +1 close-up lens is generally chosen for head-and-shoulders portraits. For extreme close-ups in which the head, or a portion of the face, fills the entire screen, stronger lenses may be selected.

Since depth of field may be limited, particularly when you use wide apertures to permit faster shutter speeds for hand-held photography, the distance from supplementary lens to subject is generally measured to the eyes, or the eyes are used as the focusing point with single-lens reflex cameras.

When photographing children, best results are achieved when you lower the camera and take the picture from the child's eye level. To emphasize the child's small size, allow slightly more room between the top of the head and the top of the frame than you would with an adult. For portraits of older persons, or romantic effects, the close-up lens can be combined with a low-contrast or diffusion filter to soften facial lines.

Flowers

Closeups of flowers are generally best when you firmly support your camera on a tripod or against some solid object such as a stone or log. A piece of colored cardboard can be used to provide a simple background, white cardboard can be used as a reflector, and clear plastic can serve as a wind shield and may be within the field of view so long as it is out of focus. With some, but not all, color-slide films, you may want to use one of the 81 series of light balancing filters to eliminate the bluish cast when the flowers are in shade, particularly if pale or white blossoms are being photographed.

Electronic flash daylight film can be used indoors or out to provide the primary light source. This has the advantage of permitting you to use small apertures, and the short exposures that the electronic flash provides eliminates the magnification of camera or subject motion that can occur in close-up photography.

Insects

Fairly strong close-up lense in use with normal camera lenses are generally best to photographed mounted insects. With live specimens, a long lens is often preferred because it increases working distance. The increased distance allows you to place lights more easily and there is less chance of disturbing the subject.

Insects photographed outdoors can sometimes be captured on film using the "action-frame" method. In this system, the camera is set up and a wire frame constructed that covers the exact field of view of the lens. The photographer watches his subject, and when it enters the frame, he makes the exposure. For convenience, the frame may be attached to the camera with a wire that puts it at the correct distance from the supplementary lens.

Small Objects

As with insects, small objects such as coins require fairly strong supplementary lenses. The camera should be firmly supported on a tripod or copystand and lights adjusted to give the emphasis to the desired details and textures. With three-dimensional subjects, out-of-focus backgrounds are generally preferred to out-of-focus foregrounds. In black-and-white photography, contrast filters of the same color as the subject, but slightly darker, can be used to improve contrast because they reduce specular reflections from the surface of the subject.

6

Creative Filter Applications

The purpose of this chapter is to suggest methods of using filters to produce unusual effects ranging from subtle color shifts for mood enhancement, through moonlight effects in daylight, to surreal scenes in brilliant false colors.

Most photographers consider these techniques as supplementary to the standard methods of using filters, and reserve the unusual effects for subjects that seem to warrant special treatment. The methods described here are only a few of the many that can be used to produce unique pictorial effects; they are presented not as ends in themselves, but as starting points for your own experimental ventures.

UNUSUAL COLOR EFFECTS

The techniques detailed below are primarily for use with color-slide film at the time the picture is taken. Special effects using color-print film are more often achieved by taking normal color negatives and then using experimental filter variations during print making.

How to Make a Special-Effect Filter

The Tiffen Roto adapter ring allows you to create your own special-effects filters. Just insert the material you wish to shoot through into the adapter ring, rotate the adapter if necessary to produce the effect you want, and make your exposure. Colored cellophane, filter gels, plastic diffraction gratings (available from Edmund Scientific in Barrington, N.J.), colored acetate (available in art supply stores), and similar materials can all be used in the Roto adapter to create variations in color and optical distortions.

To make multi-colored filters for use in the Roto adapter, try fastening small pieces of colored acetate or gelatin filter onto a piece of clear acetate using transparent tape. By using several colors pieced together in a pattern, unusual effects can be created.

A clear glass filter, normally used to protect a lens from corrosive elements such as salt spray, can also be turned into a special-effects filter. For example, you can create a diffusion filter by smearing petroleum jelly onto the clear filter. The tiny grooves left by your finger will produce different types of image distortion. Smearing the jelly with horizontal strokes will break up horizontal lines in the picture and create normal diffusion of verticals, and a circular application will produce overall diffusion similar to that created by a diffusion filter. By leaving a clear spot in the center and building up the thickness of the jelly toward the edge of the filter, you can create a vignette effect.

Color Enhancement and Alteration

The deliberate use of filters to emphasize or alter colors in a scene enables you to produce off-beat and interpretive effects with a minimum of effort. Although not all scenes respond well to such treatment, those that do often result in exceptional images.

The strongest alterations in color will be produced by the deep-color contrast filters used for black-and-white photography. When taken through dark red, yellow, or green filters, scenes tend to be monochromatic. The effect works best with subjects that exhibit strong contrasts of light and dark that serve to delineate form. For example, the hair of a brunette model against a light colored background appears as a dark silhouette when photographed through a deep yellow or medium red filter, whereas blond hair takes on the color of the filter and the shape of the head can be lost in the background. The most consistently effective subjects for the monochromatic rendition produced by contrast filters are those that would work well as silhouettes.

Color compensating filters can be used to enhance a particular color tone in a scene. Thus, magenta filters can bring out the dusky reds, browns, and blues of marsh land; green CC filters can emphasize the coming of spring to hills and fields; blue or cyan filters will produce cold, hard tones. Red or yellow CC filters can help suggest a warm or fiery quality in a scene.

Light-balancing, Decamired, and conversion filters can also produce unusual effects. An 82C will emphasize the bluish quality of twilight or a rainy day. Even stronger blues will be created with an 80A or 80B conversion filter, which can be particularly effective around sunrise or sunset with backlighted landscapes and white clouds that take on a brilliant icy gleam as the sun strikes them.

The warmth of a sunset can be dramati-cally enhanced by using an 81C, 81D, or 81EF filter. A moonlight effect can be simulated by using a No. 47B Dark Blue filter in sunlight and making no exposure compensation for the filter.

Effects similar to those described above can be created by using filters during slide copying. Additional variations can be produced by slide copying onto infrared color film (discussed below) using various filters.

Multiple Exposure Through Filters

Non-overlapping multiple exposures are generally made by placing your subject against a dark background, making your first exposure, then shifting the camera position so that the second subject, also against a dark background, is imaged in a previously unexposed (dark) area of the frame. When this technique is used, a normal exposure, including filter factor, is used for each shot.

When two or more overlapping images are made on the same frame, exposure will depend on the type of filter used and the subject areas that overlap. With light colored filters, you might start with a normal exposure for each image on the frame, then make additional frames with exposures a stop under and a stop over the normal setting. These "bracketed" images can then be used as a personal guide for future experiments.

A technique that frequently produces impressive images involves setting the camera on a tripod and making three exposures on the same frame through deep colored, separation filters. You could make the first exposure through a No. 25A (Red 1) filter; the second through a No. 58 (Dark Green) filter; and the third through a No. 47 or 47B (Dark Blue) filter. Use a lens hood (see Chapter 8) to avoid lens flare during the three exposures. As a starting point for exposure, take a normal reading of the scene, then increase that exposure by one stop for each of your three exposures. For example, if you are shooting in sunlight on

GAF 64 color-slide film and the normal exposure (without filter) is 1/250 sec. at $f/8$, then you would use 1/250 sec. at $f/5.6$ for the exposure through each filter.

The use of deep colored, separation filters reproduces the normal image color of still subjects, provided the camera is kept motionless and there is no film movement between exposures as the shutter is recocked for the second and third exposures. Moving portions of the composition, such as clouds or water, will appear in a rainbow of colors—red, blue, and green—where there is no overlap and intermediate colors of yellow, cyan and magenta where overlap occurs.

USING INVISIBLE LIGHT

The visible wavelengths of the electromagnetic spectrum, called *light,* are bracketed by ultraviolet radiation on the blue end, and at the red end by infrared, which means "below the red." Both infrared and ultraviolet rays can be used to create unusual pictorial effects, in both black-and-white and color photography.

Black-and-White Infrared Photography

Infrared film is frequently used in scientific, aerial, and surveillance photography. In scientific investigations its applications are wide ranging, because the infrared absorption characteristics of plants, water, animal tissue, and other substances will vary depending on the presence of disease, pollutants, and other environmental and pathological variables. In surveillance work, infrared film can be used in conjunction with infrared flashbulbs or a light source covered by an infrared filter to make photographs in areas that are dark.

Black-and-white infrared film is sensitive to blue, red, and infrared light. To gain the full advantages of the infrared sensitivity of the film, it should be used in conjunction with an infrared or red filter. For general outdoor photography, a No. 25A (Red 1) or a No. 29 (Dark Red) is usually satisfactory. For scientific work where precise wavelengths are desired, the visually opaque infrared filters such as the 87, 87C, and 89B may be employed over the lens.

Outdoors, black-and-white infrared film, with a red filter, renders blue skies, which reflect very little infrared, as black. Green foliage will appear almost white because its cell tissue reflects a great deal of infrared in addition to green. Coniferous trees, such as spruce and pine, on the other hand, appear dark. If further sky darkening or the elimination of glare on water or leaves is desired, a polarizing filter can be used in conjunction with the red filter. (If this same combination is used with normal black-and-white film, a nighttime effect is produced because both skies and trees will appear dark.)

Infrared film is frequently used in aerial photography because haze, which consists primarily of scattered blue and ultraviolet light, is virtually eliminated. On the ground, for photography of distant subjects through extreme telephoto lenses and telescopes, this property is also useful.

Exposure varies, depending on the filter used and the infrared intensity of the light source. Outdoors in direct sunlight with Kodak High Speed Infrared film and a No. 29 (Dark Red) filter, a starting point for trial exposures would be 1/60 sec. at $f/16$; under light clouds, try 1/60 sec. at $f/8$; and in moderate rain, 1/60 sec. at $f/5.6$.

Since infrared rays do not come to a focus at the same point as visible light rays, some correction in focusing is necessary. This is easily done if your lens has a small "R" on the distance scale. Focus normally, note the distance indicated by the index mark on the focusing scale, then adjust the focus so that the noted distance is opposite the "R" Alternatively, focus on the near side of the region of interest. You can find the point quickly if you shift focus back and forth across the sharp-focus position

6-1a. Normal rendition on Ilford FP4. No filter.

6-1a & b. Black-and-white infrared film will record healthy deciduous green foliage as white or light grey rather than the dark grey typical of panchromatic film renditions. Other alterations of tonal values will depend on the extent to which a subject reflects infrared. The results are frequently unpredictable without prior tests. A deep yellow, red, or infrared filter should always be used with infrared films.

6-1b. No. 25A (Red 1) filter with Kodak High Speed Infrared black-and-white film. Note the change in tonal values: leaves and shirt are lighter than normal but wall in background is darker than normal.

and stop the movement just as the image goes slightly unsharp while your focusing motion is bringing the plane of sharp focus closer to the camera.

Color Infrared

Color infrared film was originally developed for camouflage detection. It is a false-color film, which means that colors in the original scene are falsified by dyes in the emulsion so that in this case, infrared reflectivity, or lack of it, is clearly visible. Since all the layers of the film are sensitive to blue, a No. 12 (Yellow) filter is recommended, although you can also use a No. 15 (Deep Yellow), or even a No. 8 (Yellow 2). The yellow filter simply absorbs blue; it does not impart a yellowish cast to this special film. The "normal" infrared color rendition, with a yellow filter, produces blue skies and red foliage. Green paint that does not reflect infrared appears blue; red subjects that do not reflect infrared appear yellow. Infrared radiation reflected from the cells of green plants appears red.

When you become tired of blue skies and red grass, try using a No. 25A (Red 1) filter; this will turn blue skies green and green grass orange. Clouds will become yellow, and there will be a shift toward the yellow region of the spectrum. Slight underexposure will strengthen the effect and a polarizing filter may be added for increased saturation of sky and water color.

A cyan filter tends to shift greens toward magenta and yellows toward blue; a blue filter shifts cyans toward the red; and magenta filters cause blues to move toward yellow.

Since Infrared film are not given an ASA rating you must determine your own. A starting point for exposure with a No. 12 (Yellow) or 25A (Red 1) filter for general pictorial work is ASA 125. With a photoflood lamp (3400 K) try a meter setting of ASA 50. Since exposure meters do not measure the infrared reflectivity of a scene,

bracket important subject matter by making one normal exposure, another at a 1/2 stop more than normal, and a third one a full stop below normal. Slight underexposure tends to produce stronger effects.

When using infrared color, focus as you would for normal film. The "R" setting that you find on some lenses is for black-and-white infrared film only.

Ultraviolet Fluorescence Photography

Many common objects and materials, such as household detergents, plastic items petroleum products, and some printing inks, will fluoresce or "glow" in ultraviolet light. Equipment requirements for capturing this phenomenon on film are simple. First you need a source of ultraviolet light (also called *black light*) that does not emit visible light. The most readily available source is the dark blue black-light fluorescent tube, coded BLB by manufacturers. (Do not use a plain BL lamp, which also gives off white light.) Two 15-watt tubes (coded F15TB-BLB) are sufficient for most small subjects.

To photograph the fluorescence, a Skylight 1A or haze filter should be used to absorb the ultraviolet light, which would otherwise cause a blue cast on the film. Any daylight or indoor color film can be used, although faster films are sometimes preferred to cut down on the long exposure times required to capture the fluorescence.

Exposures should be determined experimentally. With two 15-watt BLB bulbs 12-18 inches from your subject, you could try 5 sec. at $f/16$ as a starting point and then bracket by making exposures at $f/11$ and $f/22$. A sensitive meter can be used; however, the reading should be taken through the same filter you are using on your camera.

For still more information on the multitude of scientific and technical applications of invisible radiation, see the Kodak books *Applied Infrared Photography* and *Ultraviolet and Fluorescence Photography*.

7

Practical Guides to Filter Selection

This chapter is essentially a reference guide designed to help you select the right filter in typical photographic situations. The chapter is arranged alphabetically, and each entry contains cross references to chapters or sections in which additional information can be found. The entries selected for inclusion here are intended to be representative of typical situations in which filters are used. No attempt has been made to be comprehensive, particularly in view of the fact that most situations require nothing more than the use of a correction filter for black and white, which is fully covered in Chapter 2, or the use of an appropriate light-balancing, Decamired, or conversion filter for color, which is fully covered in Chapter 3.

Aerial Photography

Black and white. Whether you are making snapshots through the window of a commercial airliner or doing aerial mapping with a camera mounted in a reconnaissance plane, the basic problem is the same—haze and an excess of ultraviolet light in the atmosphere. Since high shutter speeds are required to eliminate the effect of vibration and the possible blurring of objects on the ground due to the speed of the aircraft, a minimum of filtration is generally preferred. A No. 3 (Aero 1), requiring no exposure compensation, may be selected.

For greater haze penetration, use a No. 6 (Yellow 1) or No. 8 (Yellow 2). Additional haze penetration can be achieved by using deeper contrast filters, but an increase in exposure is necessary. For maximum haze penetration, high-speed infrared film with a No. 15 (Deep Yellow), No. 16 (Orange), or No. 25A (Red 1) can be used.

Color. A Haze 1 is recommended for general-purpose use in color aerial photography. For greater haze penetration, you can use a Haze 2A, UV15, UV16, or UV17; however, these filters will give progressively warmer overall color renditions.

Architecture

Black and white. For outdoor photographs of buildings, monuments, statuary, landscaping, and other architectural subjects, most professionals use a No. 8 (Yellow 2) to achieve correct tonal values. When a building or other subject is to be fully documented, overall views through a No. 15 (Deep Yellow) or No. 16 (Orange) are also made if blue sky is included in the scene. Although a Deep Yellow or Orange filter will darken foliage, the resulting dark sky and bright clouds will emphasize the dramatic setting of the subject. Views through a No. 25A (Red 1) or No. 29 (Dark Red) may also be taken for maximum dramatic impact.

When photographing architectural details

indoors with daylight or electronic flash, no filter is needed. With tungsten illumination, a No. 11 (Green 1) can be used to achieve accurate tonal values. The detail in wood paneling and furniture can be enhanced by choosing a filter of a similar color to the wood, but slightly deeper. (See "Wood Grain," below.)

Color. Filter as required for correct color. (See Chapter 3; see also "Interiors." below.)

Art

Black-and-white records of paintings are generally made with studioflood or photoflood illumination and accurate tonal rendition is important. A No. 11 (Green 1) will provide correct tonal values with Type B film. To eliminate glare on reflective surfaces, use a polarizer. If this is not sufficient, then use polarizing material in front of the lights as well. Be sure to make exposure readings through the filter (see Chapter 4).

For archival purposes, infrared photographs of paintings may also be made. A 25A (Red 1) filter should be used with black-and-white infrared film. If a recording of infrared reflection only is desired, you can use a No. 87 or No. 87C, which transmit no visual light.

Color. Outdoors, use light-balancing or Decamired filters to provide correct color in other than the standard mixture of sunlight and skylight (see "Daylight," below).

In artificial illumination, use the appropriate conversion, light-balancing, or Decamired filter to achieve correct color balance.

Artifacts

Black and white. When artifacts, small sculpture, and other objects are photographed in daylight, the north light preferred by portrait photographers provides a soft, pleasing illumination. A polarizer will effectively eliminate glare spots; however, north light is partially polarized and expo-

sure readings should be made through the filter. A No. 8 (Yellow 2) correction filter will provide proper tonal rendition and may be used with a polarizer.

With photoflood illumination, no filter is necessary, although a No. 11 (Green 1) can be used for critical work. For recording purposes, it is sometimes necessary to bring out subtle detail, in which case a filter of the same color as the subject, but slightly darker, may be used. For example, red lines on a red bowl can be brought out by using a No. 25A (Red 1) or No. 29 (Deep Red) filter. A control shot without filter should also be made, because the unfiltered rendition may be satisfactory.

Color. Filter as required for correct color (see Chapter 3). To reduce or eliminate reflections and glare, use a polarizer and polarize the light source if possible (see Chapter 4).

Tiffen close-up lenses can be used with either black-and-white or color film to get large images of small objects (see Chapter 5).

Beaches

Black and white. Use a No. 8 (Yellow 2) or No. 9 (Yellow 3) to darken skies and eliminate excess ultraviolet illumination which can cause slight fogging. The brilliant light reflected from sand and water can cause an average meter reading to underexposure, in which case you can open up an extra 1/2-1 *f*/stop in addition to the 1 stop increase for the filter factor.

For dramatic skies and sparkling water, try a No. 15 (Deep Yellow) or No. 16 (Orange) filter.

Color. Use a Skylight 1A, Haze, or UV filter to eliminate the bluish cast caused by excess ultraviolet light (see Chapter 3). A polarizer can also be used to provide some sky darkening as well (see Chapter 4).

Clouds

Black and white. To bring out clouds against a blue sky in black-and-white photography, any yellow, orange, or red con-

trast filter may be used. These filters will have no effect with overcast skies. A polarizer can be used for slight darkening of blue sky. To darken an overcast sky, try a Tiffen Sky-Control filter (see Chapter 4).

Color. To darken blue skies and bring out white clouds, use a polarizer or sky-control filter (see Chapter 4).

Color Casts

Blue, red, or yellow casts can be controlled by using the appropriate skylight, haze, light-balancing, Decamired, or conversion filter (see Chapter 3). Bluish casts in the mountains or at the beach can generally be eliminated by using a Skylight 1A or Haze 1. Bluish casts when the sky is hazy can be controlled with a Skylight 1A or with an 81A or DM R1$\frac{1}{2}$ filter. Under overcast skies, or in open shade, the stronger filtration provided by an 81C or DM R3 may be required, although a Skylight 1A filter may be adequate. Stronger filtration may be required when the sun is hidden behind clouds or behind the horizon and your subject is illuminated by blue skylight. Try an 81D, 81EF, or an R6 as a starting point in those situations.

The reddish cast caused by early-morning or late-afternoon sunlight can be controlled with a B1$\frac{1}{2}$ or 82A filter. With clear flash and daylight films, use an 80C or B6 + B1$\frac{1}{2}$. For filtration requirements with general household lamps, see Chapter 3 and "Interiors," below.

Color casts can be caused by light reflected from colored surfaces in the immediate vicinity of your subject. For example, light reflected from green grass will have a greenish cast, light reflected from a red-brick wall onto pale skin will result in a sunburned appearance, and flash illumination bounced from walls and ceilings will take on the color of the surface from which it is bounced. The exact effect of colors in the immediate vicinity of your subject is difficult to predict because the eye readily adapts to minor changes in the

color of light, making such changes "psychologically invisible" until the film is processed. These color casts though, are quite apparent when the photographs are viewed. They can be controlled with combinations of color-compensating filters, but the exact filtration required will depend on the individual situation. As a rule of thumb, choose the CC filter that is complementary to the anticipated color cast.

Some experimentation will be required before the exact filter or filter combination is found (see Chapter 3). If you are uncertain about the nature of a local color cast, and accurate color rendition is important, then it may be preferable to move the subject to some other location.

Color Cast	CC Filter for Correction
Blue	Yellow
Green	Magenta
Red	Cyan
Yellow	Blue
Magenta	Green
Cyan	Red

Copying Problems

Black and white. In copying documents, stamps, photographs, and other flat subjects, filters are ordinarily used to improve contrast, eliminate reproduction of stains, or eliminate reflections. When filters are used, an unfiltered control shot should also be made for comparison in evaluating the effect of the filtration. Often an unfiltered rendition is satisfactory.

To copy paintings, use a No. 8 (Yellow 2) in sunlight; in tungsten light, use a No. 11 (Green 1) filter. No filter is needed when copying photographs with a neutral-black image tone and white base; however, a polarizer can be used to eliminate reflections and glare from the surface. No filter is needed to copy sepia toned prints,

EXPOSURE INCREASE WITH ORTHOCHROMATIC FILMS

Filter No.	Color or Name	f/Stop Increase Daylight	f/Stop Increase Tungsten
3	(Aero 1)	1	$^2/_3$
3N5	Yellow	$2\text{-}^2/_3$	2
6	Yellow 1	1	$^2/_3$
8	Yellow 2	$1\text{-}^1/_3$	1
8N5	Yellow	3	$2\text{-}^2/_3$
9	Yellow 3	$1\text{-}^1/_3$	1
11	Green 1	—	—
12	Yellow	$1\text{-}^2/_3$	$1\text{-}^1/_3$
13	Green 2	—	—
15	Deep Yellow	$2\text{-}^1/_3$	$1\text{-}^2/_3$
16	Orange	—	—
21	Orange	—	—
23A	Light Red	—	—
25A	Red 1	—	—
29	Dark Red	—	—
47	Dark Blue	—	—
47B	Dark Blue	$2\text{-}^2/_3$	3
56	Light Green	—	—
58	Dark Green	3	$2\text{-}^1/_3$
61	Dark Green	—	—

Note: Orthochromatic films are generally used only for copying and in the graphic arts.

although No. 11 (Green 1) may improve contrast.

Faded photographs generally have a yellowish image and a No. 47 (Dark Blue) filter can be used to improve contrast. This same filter can be used to darken the rendition of red ink and improve contrast in copies of documents on which the ink has faded to yellow-brown.

To whiten the background of yellowed documents with black ink, and to eliminate yellow stains on prints, use a No. 15 (Deep Yellow) or No. 16 (Orange) filter. To darken blue letters or lines on a white background or to improve contrast when copying blueprints, use a No. 25A (Red 2).

Color. A color rendering that is an exact duplicate of an original is nearly impossible to achieve because the dyes used in color films are not perfect. When color rendition is critical, as when copying paintings for archival purposes, it is best to standardize on a single film and lighting arrangement and then experiment with color compensating filters until the desired results are achieved. In addition, light-balancing, Decamired, or conversion filters should be used to balance the light source to the film, as described in Chapter 3.

If glare or reflections are problems, polarizers can be used in front of the light sources and over the camera lens. This system can totally eliminate reflections, but it may also increase color saturation and contrast beyond that which would be apparent under normal viewing conditions. In other words, it is sometimes desirable to allow some reflections to remain. Alternatively, you can decrease color saturation and contrast by making a fogging exposure. To do this, make a normal exposure of the subject, then place a sheet of white, matte surface paper in front of the original and make a second exposure *on the same frame* through a combination of ND 1.5 and ND 0.1 filters. This fogging exposure through the neutral density filters is equivalent to about two percent of the original exposure. A similar technique can be employed to reduce contrast when making copies of slides onto reversal films. In both cases, you need a camera that has a provision for double exposure.

When copying slides onto color reversal film, some adjustments using light-balancing or color compensating filters may be necessary. The exact requirements depend on the film types and lighting source. The instruction books, supplied with more sophisticated slide-copying systems, such as the Honeywell Repronar, give extensive filter recommendations. Systems without a built-in light source generally do not include filter suggestions, and some experi-

7-1a & b. Old photographs often have yellow stains caused by incomplete washing when the print was first processed. Rubber cement used for mounting and spilled liquids, such as coffee or tea, can also stain prints. These stains can often be eliminated by copying the photo onto panchromatic film through a deep yellow or red filter.

7-1a. No filter.

7-1b. The No. 29 (Dark Red) filter has completely eliminated the stain.

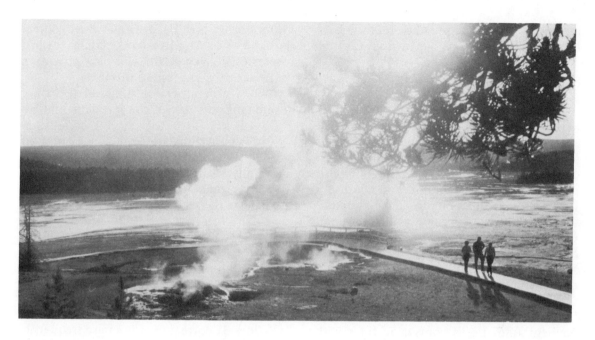

7-2a. No filter.

7-2a & b. A combination of a polarizer with a No. 25A (Red 1) filter was used to reduce glare and provide a tonal interpretation of this geyser basin.

7-2b. Tiffen SR Polarizer plus a No. 25A (Red 1) filter.

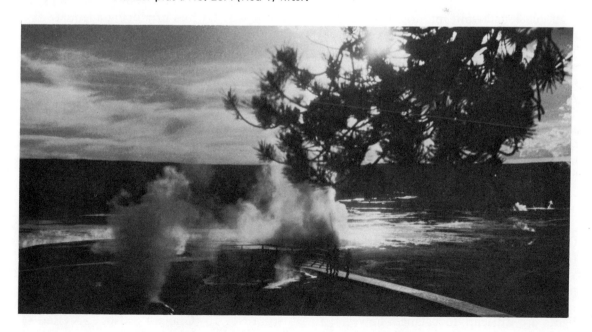

mentation may be required to find the best filter combination for your own set-up.

Flash

Electronic flash. Today, many flash units have a built-in UV filter that matches the color of the flash to the standard for which most daylight films are balanced (18-16 decamireds or 5500-6000 K). If your flash photographs are too bluish, you can use a UV16 for correction in most circumstances. With some color print films, an 81A may help prevent bluish highlights. A Skylight 1A may also prove satisfactory. With tungsten films, use the appropriate conversion filter.

Blue flash. Blue flashcubes and flashbulbs generally require no filtration with daylight film. Use a conversion filter with indoor films.

Clear flash. Clear flashbulbs, although not popular today, are still available; with zirconium foil-filled flashbulbs, use an 80D, and with aluminum foil-filled flashbulbs, try an 80C.

Interiors

In black-and-white photography, rooms and other interiors present no special problems. On the other hand, the frequent presence of mixed lighting sources presents special problems in color photography. If you choose to photograph with the existing daylight, all room lights can be turned off and electronic or blue flashbulbs used for fill-in illumination. Alternatively, household tungsten bulbs can be replaced with blue coated photographic lights, which are somewhat warmer than daylight but generally produce satisfactory results.

The color quality of light entering through windows depends on the nature of the outdoor environment. In some instances no filter is required; for certainty, make tests.

Fluorescent lights mixed with tungsten lights are difficult to balance; however, if fluorescents are the principal light source, use an FLD® filter and daylight film. Occasionally, an 81EF will also provide a satisfactory compromise filtration.

When general-service tungsten lights are dominant, use tungsten-type film and an 82C or B3 filter for general correction. With Type A film, use an 82C + 82 or a B3 + B1½ as a starting point. An 82C is also generally satisfactory for candlelight, since it allows some of the warmth of the light to remain in the scene.

Landscapes

Black and white. The use of filters to bring out subtle tonal variations is an important ingredient in the camera work of many serious photographers working in this genre. The No. 8 (Yellow 2) and No. 9 (Yellow 3) correction filters are frequently used at the seashore and in wooded areas. When dramatic skies are desired, a No. 15 (Deep Yellow) or No. 16 (Orange) may be employed. In the mountains, deeper filtration is seldom required. Yellow and orange filters are particularly useful in damp coastal areas because they help cut through haze and bring out subtle variations in damp wood while producing adequate sky darkening. When photographing green vegetation, the No. 11 (Green 1) is useful for bringing out subtle details.

In drier climates, and in desert areas, the No. 11 (Green 1), No. 13 (Green 2), and No. 23A (Light Red) are popular for separating the dusky greens and tans of desert foliage and sand, which are generally rendered as a dull grey in unfiltered shots. For even greater tonal contrasts a No. 25A (Red 1) or No. 58 (Dark Green) is effective. At twilight, in dry areas, dark blue filters such as the No. 47 or No. 47B can be used to increase subject contrast, but blue filters should not be used in humid weather unless you want to create a fog effect.

To photograph yellowish or reddish leaves in black and white against a blue sky, try a No. 16 (Orange) or No. 25A (Red 1),

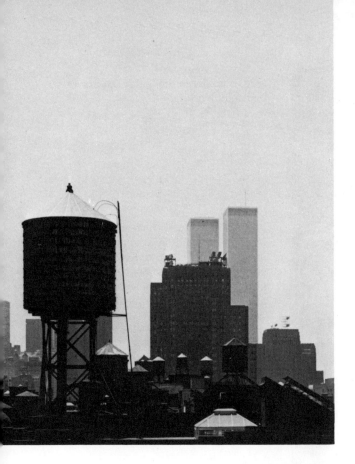

7-3a. Blue sky in New York City. No Filter.

7-3b. No. 15 (Deep Yellow) filter (above right)

7-3c. No. 25A (Red 1) filter (right)

which will produce light leaves against a dark sky. When leaves turn brown, a No. 29 (Dark Red) can produce a similar effect. To render the colors of fall as dark tones against a light sky, try one of the dark blue filters such as the No. 47B.

Color. The Skylight 1A is the most useful filter for general-purpose color photography with most daylight films. Alternatively, a Haze 1 may be used. For greater haze penetration with increased image warmth, use a Haze 2 or UV15 filter. Additional correction for bluish, north light or overcast skies can be achieved using the 81 series or Decamired R series of light-balancing filters. In the early morning or late afternoon, an 82A (B1½) can be used to eliminate an excessively warm cast.

7-3d. Blue sky in the South Dakota Badlands. No filter.

7-3a-f. The sky darkening effect of a filter depends in great part on atmospheric conditions. Even the strongest filters have only a moderate effect on the smokey blue sky typical of New York and other major cities (see photos on page 81). Strongest results are achieved with the brilliant blue skies typical of desert and mountain regions.

7-3e. No. 15 (Deep Yellow) filter.

7-3f. No. 25A (Red 1) filter.

Color compensating, light-balancing, or Decamired filters can be used to emphasize or de-emphasize the quality of existing light to create subtle variations in overall color quality and mood. (See Chapter 6 for some suggested variations.)

Portraiture

Black and white. Outdoors, the blue sky is often used as a background for portraits and figure studies; however, if one of the yellow filters is used for sky darkening, pale-skinned subjects may appear slightly chalky. In this case a No. 11 (Green 1) is preferable. If a deeper yellow or orange filter is used, pale faces become very chalky and lips are rendered too light; having the subject use darker lipstick may help under these conditions. Occasionally a blue filter may be selected to turn a blue sky white in the finished print. In this case lips will be rendered too dark unless a very light lipstick is used.

For portraiture in tungsten lighting, use a No. 11 (Green 2) for general-purpose tonal correction with male subjects. For a more rugged appearance with male subjects, use a No. 13 (Green 2).

Electronic flash does not generally require corrective filtration. And filters are generally not used by photographers specializing in candid portraiture.

Color. If you find that color transparencies made with electronic flash have a bluish cast, try a UV15 for correction. A UV15 or 81A may also improve results when using electronic flash with color print film. For correct flesh-tone rendition under existing-light conditions, light-balancing or Decamired filters may be required to change the light so that it approximates the standard for which the film is balanced. Exact requirements will depend on lighting quality and the film used. Serious photographers should experiment until filtration is found that suits their personal tastes. For example, when making a portrait of a light-skinned person by north light, a photographer using Kodachrome 25 may select an 81A or R3 whereas a person using GAF 64 may find that an 81A or R1½ is adequate for his purposes.

Sports

The general requirements for color or tonal correction are the same here as in any other area of photography. When photographing water sports, a polarizing filter may be useful for elimination of glare, provided the two-stop exposure increase still permits the use of fast shutter speeds. With extreme telephoto lenses, a Skylight 1A or Haze 1 is useful in color work and a yellow or orange filter will help reduce the greyish veil that sometimes appears in black-and-white photographs.

To use slow shutter speeds with fast films, so that pan and blur shots may be created, use neutral density filters (see Chapter 4).

Underwater Photography

The color quality of photographs taken underwater depends on the lighting source used, water depth, and water quality, as well as film type. Unfortunately this means that specific filter recommendations are almost useless. For color photographs made in clear water at shallow depths, a CC30R may provide general-purpose correction.

Wood Grain

When you photograph wood or wood furniture, the object is generally to show both detail and grain. For this purpose, a filter of a color similar to the wood may be selected for black-and-white photography. For example, a No. 23 or 25A works well with reddish woods such as rosewood or mahogany; a No. 15 (Dark Yellow) or No. 16 (Orange) filter can be used for yellowish woods such as maple, oak, or pine.

8
Technical Problem Solving

This chapter is intended primarily for experienced photographers who need information about the mechanics of filter fitting, determination of exact filter factors, and selection of filters for scientific and technical applications. It also includes information of a more general nature on standards for viewing prints and slides and on the creation of effective audio-visual slide presentations.

TIFFEN LENS ACCESSORIES

Adapter Rings

The question that most often confronts photographers who decide to make a substantial investment in filters is whether to purchase direct-fitting or series-size filters. There are advantages to both systems. The photographer who owns one camera with a non-interchangeable lens, or the photographer who purchases lenses that all have the same filter-mount diameter, will probably find the direct-fitting type most convenient. With the aid of step-up and step-down rings, these filters can also be used with lenses that are a few millimeters larger or smaller than the photographer's standard.

On the other hand, the photographer who sticks to one filter size when buying a system of interchangeable lenses loses flexibility, because the faster wide-angle, telephoto, and zoom lenses generally have large front elements for speed, and therefore require large size filters. If you want to use your sets of filters with a variety of filter mounts, then series-size filters are more convenient. Series 7 is the most popular among 35mm photographers, although the larger and more expensive Series 8 will fit more lenses and can be used with most zoom lenses on Super 8 movie cameras as well. As a rule of thumb, standardize on the series size that will fit most of your lenses. Step-up or step-down adapter rings will allow you to use your filters on lenses that require adapters that are smaller or larger than those available for the series size you have.

Tiffen adapter rings, step-up and step-down rings, retaining rings, lens shades, and lens caps are kept in stock for most cameras and lenses. When they are not available from stock, Tiffen can manufacture these accessories on a special-order basis for any camera or lens in the world.

Tiffen retaining rings, which hold the filter in place in the adapter ring, and permit the use of two filters simultaneously, are available for all series-size adapter rings.

Step-Up and Step-Down Rings

A step-up ring allows you to use the next larger series-size filter, so that you could, for example, use a Series 8 filter with a Series 7 adapter. Also available from Tiffen

are direct-fitting step-up rings that thread directly into the lens mount so that you can use direct-fitting, screw-in filters with smaller diameter lenses. For example, direct-fitting step-up rings for lenses with a 49mm screw-in filter mount allow you to use 52mm, 55mm, 58mm, or 62mm screw-in filters, depending on the ring selected. Stepping up to a larger diameter filter presents no photographic problems. The step-up rings simply allow you to use a single filter with a greater variety of lenses.

Step-down rings that permit the use of the next smaller filter size are also available. These are most effective when used with lenses in the normal to telephoto range, which have relatively narrow angles of view. Occasionally you may run into problems with wide-angle lenses, since the edge of the filter or the step-down ring may come into the field of view of the lens and cause vignetting at the corners of the picture. If you have a through-the-lens reflex viewing camera, this problem can be observed directly in the viewfinder. With rangefinder and other indirect viewing systems, you can make a test shot to insure that there is no image cut-off.

In series sizes, step-down rings allow you to use Series 6 adapter rings with Series 5 filters, Series 7 rings with Series 6 filters, and so on. Direct-fitting step-down rings that thread into the lens mount are also available for converting small, direct-fitting screw-in filters for use with lenses having larger filter mounts.

Step-up and step-down rings may also be used when you want to combine two filters of different series size. Generally, the smaller filter should be used first, in an appropriate adapter ring, then a step-up ring into which you fit the larger filter. This procedure minimizes the possibility of vignetting.

Lens Shades

Tiffen lens shades are available in standard-round, wide-angle, and square types. Series-size lens shades screw directly into filter adapter rings and can be used to hold a filter in place. Screw-in lens shades are available in a variety of standard sizes and can be screwed directly into the lens filter mount or onto the front of Tiffen screw-in filters.

Serious photographers should make it a practice always to use a lens shade when filters are used. The lens shade helps prevent flare caused by light sources that are just outside the field of view of the lens and that strike the filter surface at an angle, causing unwanted reflections to be transmitted into the lens.

Professional Filter Holders

The Tiffen Professional Filter Holder is designed to accept both square filters (glass and gelatin) and series-size, round filters. Finger-tip pressure allows you to turn the filter holder to the vertical or horizontal for easy access to the filter chamber. A standard Tiffen adapter ring secures the filter to any lens.

These round-square holders are available for the following combinations of square and series-size filters: 3" X 3" glass or gelatine square filters and Series 8 round filters; 3" X 3" glass or gelatine filters and Series 9 filters; 4" X 4" glass or gelatine filters and Series 9 filters.

Professional filter holders are most often used in studio, technical, and motion picture photography.

Filter Kits

This section provides some suggested combinations of filters that are suitable for general amateur and commercial photography. They are not the only combinations that might be selected, and photographers who do not find their favorite filters on the list should not be disappointed. For many experienced photographers, filter selection is deeply involved with their own style and methods, and what is appropriate for one may not be right for another.

STARTER SET FOR BLACK-AND-WHITE PHOTOGRAPHY

Filter No.	Color or Name
8	Yellow 2
11	Green 1
12	Yellow
15	Deep Yellow
25A	Red 1
29	Dark Red
47B	Dark Blue
58	Dark Green

STARTER SET FOR COLOR PHOTOGRAPHY

Filter No./Name
Skylight 1A
DM filter set
FLD
FLB
Polarizer

FILTER VARIABLES

Darkroom Contrast Control

Contrast filters are used in black-and-white photography to separate closely related tones, which may be difficult or impossible to separate by varying the contrast of printing papers. Once the initial separation of tones has been achieved, selection of a printing paper with the appropriate contrast characteristics allows you to "fine-tune" tonal separations.

Additional control may be achieved by using developing procedures that alter the basic contrast characteristics of the negative. For example, overexposure and underdevelopment of a film will lower contrast; to increase contrast, underexpose and overdevelop. The latter procedure will exaggerate the effects of on-camera filtration. Contrast control during development primarily affects the middle tones and highlights. It has little effect on the darkest tones.

Darkroom procedures for contrast control do not replace on-camera filtration. Their principal effect is to emphasize the difference between tones that are already well separated on the negative. Clouds in a blue sky, or the elimination of aerial perspective, can be rendered only with on-camera filtration.

Separation Filters

Color separation, or tri-color, filters are used in special applications to make blue, green, and red records of colored subjects. Normally, these records are made on panchromatic black-and-white emulsions, although they may also be made on color films for special effects as described in Chapter 6.

Tri-color filters each transmit roughly one-third of the visible spectrum and are used principally to make color separation negatives that can be superimposed by optical or mechanical means to bring the image together again.

When separation negatives are made from the original subject, standard tri-color filters are used. These are the No. 47B (Dark Blue), No 58 (Dark Green), and No. 25A (Red 1). The transmission characteristics of these filters overlap slightly in the cyan and orange regions of the spectrum, which is appropriate when making separations from original copy. The separation negatives produced may be used for making dye-transfer prints or photomechanical plates for printing.

Separation negatives may also be used in black-and-white photographic printing by exposing each negative successively, in register, on the same sheet of printing paper.

By varying the exposure given to each negative, infinite variations in tonal contrast may be produced. The technique can be used as a last resort in product photography when normal filtration procedures will not produce acceptable contrast differentiation with multicolored subjects.

Today, most color separations are made from colored photographic reproductions, usually color transparencies or prints, which contain only three dyes. In this case, a narrower separation of colors is required and narrow-cut tri-color filters are used. These filters are the No. 47 or No. 47B (Dark Blue), No. 61 (Dark Green), and No. 29 (Dark Red). They have little or no overlap in their transmissions, but require longer exposures than the standard tri-color filters.

Estimating Filter Effects

For purposes of scientific description, the effect of a filter is usually shown on a graph by plotting the percent transmittance against wavelength. The resulting line of the graph is known as the *filter curve*. The visible region of the spectrum extends from about 400nm (blue) to 700nm* (deep red) and most filter curves show this region in addition to a portion of the ultraviolet and sometimes the infrared, depending on the filter and its customary function.

Filter curves, or spectral transmission graphs as they are sometimes called, are of no value in general photography because most subjects contain varying mixtures of color and will have varying color qualities, depending on the light source. They are of real use only in the well-equipped laboratory, and for this reason are not included in this book. Research scientists and technicians who need to have this data can get it by writing to Tiffen for the *Tiffen Photar Filter Glass Catalog* No. T371 (Price $2.00 plus tax).

*nm-*nanometer,* one billionth of a meter. This unit was formerly known as the *millimicron.*

Control Through Exposure in Black and White

As pointed out earlier, exposure factors are only guidelines based on average lighting conditions. In black-and-white photography, with general-purpose panchromatic film, two factors are given, one for average daylight and another for tungsten illumination. These factors are generalities that can be modified according to the results desired.

The classic example of the red apple hanging among green leaves provides a convenient model for the examination of exposure variables. If we choose to photograph this subject through a red filter, we ordinarily select one of two types of exposure. The usual exposure is one that will render the red apple with its normal luminance values when the negative is printed at a standard printing exposure, i.e., a time-*f*/stop combination that produces correct black-and-white prints with normal negatives. The red apple will be normal but the green foliage will be dark because the green radiation has been absorbed by the filter.

A second type of exposure could be made in which the green portions of the subject would be rendered in their normal tones in the final print. In this case, the red apple would be very light.

A suggested filter factor generally is based on a neutral grey subject, as explained in the section below on filter factors. In the case of the red apple and green leaves, additional darkening of the leaves through a red filter would be achieved by underexposing slightly, that is, by using a slightly smaller filter factor than the one suggested. To achieve normally rendered leaves and a very light apple, additional exposure would have to be given.

Ordinarily underexposure or overexposure is not called for. The suggested factors are adequate for sky darkening and other general situations. It is only when a subject requires special treatment that ex-

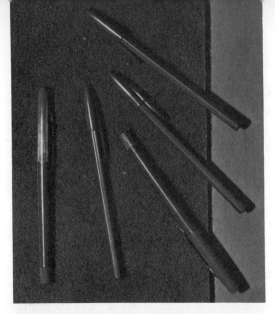

8-1a. No Filter. Red pens lie on top of a green scouring pad; on the top and right hand edge is a neutral grey card.

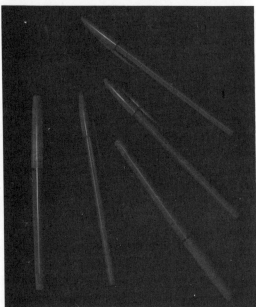

8-1b. No. 25A (Red 1) filter. One-half f/stop exposure increase over that required for an unfiltered shot produces pens that are similar in tone to the unfiltered photo, but both grey card and green pad are underexposed.

8-1c. (below left) No. 25A (Red 1) filter. Opening up the lens 2-$\frac{2}{3}$ f/stops, the recommended exposure increase for tungsten light, produces a correctly rendered grey card. The red pens are now light and the green pad is dark. This exposure has produced optimum separation between green and red while maintaining correct neutral values.

8-1d. (below) No. 25A (Red 1) filter. A four f/stop exposure increase produces a green pad that is similar in value to an unfiltered shot, but the red pens are now extremely light and some detail is lost.

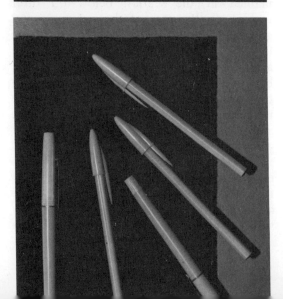

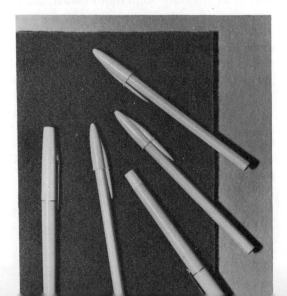

posure variables need to be called into play.

When a monochromatic subject, such as the veining and grain patterns in a piece of mahogany or a red design on a red bowl, is to be recorded with the longest possible scale of tones, that is, with maximum detail differentiation, then choose a filter that transmits the detail of the wood or the bowl—in this case a red filter. The same principle applies when photographing the subtle shades of green grass in spring—select a green filter.

When selecting a filter of the same color to increase detail differentiation, use a lower filter factor than you would normally, since a smaller proportion of the colors will be absorbed by the filter than would be the case when photographing a subject with a full range of colors. Overexposure, which can be produced by a normal filter factor with monochromatic subjects, will reduce the selectivity of the filter when used for detail differentiation.

Some subjects are of inherently low contrast, such as a blue design on a white bowl. In this case a filter that holds back the subject color should be chosen to increase contrast—select a red filter. When using a filter for contrast, the object is to overexpose the background while correctly exposing subject detail; hence, a normal or higher-than-normal filter factor should be given.

Filter factors lower than suggested should be used when the color of the subject to be correctly rendered is the same as that of the filter. Higher factors are assigned when the color to be correctly rendered is opposite to the color of the filter, or to state it more accurately, coincides with the filter's region of maximum absorption.

It is impossible to achieve both maximum contrast and maximum detail. For this reason, two photographs are often required for comparison purposes in scientific photography, one filtering for maximum detail, the other for maximum contrast.

Determination of Filter Factors

A filter factor is a ratio between filtered and unfiltered exposures of same subject, that gives images of the same density. Since the only subjects that retain their relative luminosities after introducing a filter are black, grey, and white, the usual practice for determining a filter factor is to photograph a neutral test subject under the lighting for which the factor is to be determined. A neutral-toned black-and-white print may be used as a test subject, or you can photograph a neutral grey card, such as the Kodak grey card, which can be purchased from some photo dealers.

One test procedure is to light the grey card evenly with daylight or with two tungsten lights placed at 45° angles to the surface of the card, one on either side. Focus the lens on infinity and move the camera toward the subject until the grey card fills the image area. Make an exposure reading of the grey card, adjust the camera accordingly, and make an unfiltered exposure. Now place the filter over the lens and make a series of exposures beginning with the standard, unfiltered exposure and opening up the lens 1/3 or 1/2 f/stop for each succeeding shot until you have gone one or two full f/stops beyond the suggested factor for the filter. (Do not adjust shutter speed for this test, since shutter speeds are usually less accurate than f/stop adjustments. (Use a shutter speed of 1/10 sec. or faster to avoid reciprocity failure, which would invalidate the test.)

Keep careful records of each shot. If the test is being made in black and white, develop according to your standard procedure, then compare the unfiltered control shot with the test series. The filtered negative that has the same density as the control negative will be the one taken with the correct exposure compensation in f/stops. If you prefer, you can make a contact print of all negatives and use this print for comparison purposes.

If you make your test on color film, simply compare the filtered slides with the

unfiltered control slide using a slide-sorter or light box. If you have your slides processed by a custom photofinisher, remember to tell him to number the slide mounts so that you can tell which exposure is which. Not all custom labs number slides.

If you make your test series on color negative film, have a single contact sheet made that contains all the shots in the series, including the control shot, so that you can make a comparison. Mass-produced prints from color negatives will not be valid for test purposes, because exposure adjustments are made automatically during printing.

In the above test, the filtered shots are compared only with the unfiltered control shot, not with the original subject. If the control shot is too light or too dark by no more than 1/2 stop, it should not significantly affect the validity of the filter factor, but it should alert you to possible variations introduced by your camera, meter, or metering method. For an exact method of determining a personalized ASA speed that will compensate for variations in your camera or meter, read *Zone VI Workshop* by Fred Picker (AMPHOTO, 1975).

The use of a neutral subject will produce filter factors similar to those suggested throughout this book. Naturally if you are using a filter of the same color as your original, to filter for detail, a different factor will be required. If you choose to test for this factor, replace the grey card with your subject and use the test procedure described above. To find a factor that will produce correct luminance values when filters of an opposite color to the subject are used, follow the same procedure, with the original subject, not the grey card, and extend the test two-four stops further than the standard filter factor.

Keep in mind that experimental determination of filter factors is seldom called for. The neutral-subject factor will coincide closely with the factors given for each filter

in this book, and bracketing exposures in uncertain situations will take care of most unusual subjects.

When exposure readings are made directly through the filter, the resulting metered reading may vary somewhat from the exposure derived from an unfiltered reading and application of an exposure factor. This is due to variations in subject color, lighting conditions, and the meter's sensitivity to various colors of light. Although seldom a problem with the filters used in color photography or with light colored contrast filters, under- or overexposure can be a problem with deep-colored contrast filters and CdS (cadmium sulfide) meters. The simplest way to check for this problem is to meter a grey card with and without a filter in front of the meter and see what factor you get. Compare this with the suggested filter factor to find the additional compensation, or reduction in compensation, that will be needed when using the tested filter in front of the meter or on a through-the-lens metering camera. If you are using a fully automatic camera with a manual override, use the camera in the manual mode, make your through-the-filter reading, then adjust exposure according to your previous test. If you have a fully automatic camera with no provision for manual exposure override, then you will simply have to accept whatever exposure the camera gives you. The results will usually be acceptable. With red filters, which tend to lead to underexposure with automatic cameras, results may be even more dramatic than a correctly exposed shot.

Combining Two or More Filters

To find the filter factor for two or more filters in combination, multiply the factors or add the exposure compensation in f/stops required for each filter.

When you combine two or more contrast, neutral density, or color filters, the

order in which they are combined is unimportant. On the other hand, when you combine a close-up lens or polarizing filter with ordinary filters, then the close-up lens or polarizing filter should be closest to the camera lens. Put the close-up lens on first when combining it with a polarizing filter. For example, you might have the following combination with series-size filters: adapter ring, +4 close-up lens, retaining ring, series-size polarizer, retaining ring, No. 11 correction filter, and lens hood to hold the last filter in place.

Color Film Variables

The standard light source to which daylight-type color films are balanced varies among manufacturers. Since no true color temperature can be assigned to daylight (most subjects are illuminated by varying combinations of sunlight, skylight, and reflected light), an approximation is made and assigned a color temperature value. For example, Kodak films are balanced for 5500 K or 18.2 decamireds; GAF and Agfa films are balanced for 6000 K or 16.6 decamireds. There are also differences in the dyes used for the colors in the film. As might be expected, these variables result in different color renditions under identical photographic situations.

Other factors that may influence color are the camera lens, altitude, geographic latitude, time of year, and atmospheric pollution. The viewing system you use to evaluate your transparencies and prints will also influence color.

As a result of the many variables involved, experience and common sense are required to select filters effectively for use in daylight. Serious photographers can develop personal guidelines by running tests with their favorite films under typical conditions. To make the test, a control shot is made without filter and then a series of shots is made with light-balancing or DM filters using progressively greater filtration.

Keep notes of the lighting condition and filtration for each shot. A typical test shot would include a model, some sky, a neutral background, and some brightly colored clothing. Direct sunlight, hazy sunlight, open shade illuminated by blue sky, backlight, overcast, and heavy overcast are typical conditions under which test series could be run.

Color tests should be made at exposure times that are normal for the film. Very short exposures, such as those provided by some automatic flash units at close range, and exposures longer than a few seconds may cause reciprocity failure with daylight films; this will alter the color balance.

FILTERS FOR SCIENCE AND TECHNOLOGY

Tiffen Photar Filters are carefully designed and precisely manufactured to meet the stringent requirements of scientific and technical applications. They are available in a wide range of types, covering wavelengths from the ultraviolet, through the visible spectrum, and well into the infrared to meet the needs of scientists and engineers who seek to control or alter the intensity of radiant energy either neutrally, or selectively, according to wavelength.

The filters detailed in this book are those most widely used in general and commercial photographic applications; however, the Tiffen Manufacturing Corporation is capable of making a wide range of filters to fit specific requirements in scientific and technical areas. For example, Tiffen filters are normally supplied in the common circular (disc) shape with diameters ranging from 0.250-13 inches. Special diameters can be held within 0.001 inch of the specified size, and other shapes, such as elliptical or rectangular, can be made to order. Unlike the typical solid glass filter, the thickness of a Tiffen Photar filter may be specified in a range of thicknesses from

0.025-0.625 inch without significant effect on transmission.

Customers may order a wide range of filters not covered in this book, and have filters made to exacting specifications.

In the design of certain optical systems of high performance, it may be required to specify the tolerances of flatness and parallelism for the filter surfaces. For example, the surfaces may be required to be flat within one-quarter wavelength of sodium light and parallel within 10 seconds of arc. Tiffen filters of appropriate thickness can be made to such specifications. Filters may also be specially ordered with hard magnesium-flouride coatings.

Scientists and engineers requiring specific information about Tiffen filters for technical equipment or applications can order the *Tiffen Photar Filter Glass Catalog* ($2.00) from Tiffen or send a request for specific information directly to Tiffen Manufacturing Corp., Industrial Products Division, 61 Jane Street, Roslyn Heights, N.Y. 11577.

PRINTS AND SLIDES FOR VIEWING

No picture is finished until it is ready to be presented to its intended audience. Therefore this last section is about how to look at, evaluate, and show finished prints and transparencies.

Color Prints

The quality of color prints is more difficult to evaluate than the quality of either color slides or black-and-white prints. Large-volume photofinishers use automatic processing machines that are set up to print standard negatives. If your negatives are non-standard for any reason, including unusual subject matter, unnatural color casts are likely to appear in the prints. Determining if the color cast was caused by processing or improper filtration is sometimes difficult.

The color of the viewing light can also influence judgment regarding the quality of color prints; however, the eye readily adapts to such variations in color, and for general viewing purposes, lighting quality need not be considered a problem. When prints are evaluated for purposes of reproduction, a standard light source such as the Macbeth light can be used for critical comparisons. Custom laboratories that specialize in prints for reproduction print for a variety of standard light sources, and the laboratory's trained personnel can provide advice about on-camera filtration and other procedures that will aid in making accurate color prints.

Many commercial photographers prefer to make all their color shots on color transparency film and have color prints made from selected transparencies because the transparency provides a standard of reference, against which the print can be readily evaluated.

Wedding photographers who use color negative film for producing double-exposure or montage effects should be particularly careful about on-camera filtration. For example, when a shot taken in church is about to be combined with a portrait made by electronic flash, the shot made in church should be filtered so that its color quality and printing characteristics are reasonably close to those of the portrait.

Slide Presentations

The method used to view slides will make a major difference in the way they are evaluated. There is a greater tolerance for variations among slides when they are projected in sequence in a darkened room than there is when they are reproduced side by side in the pages of a magazine or laid out side by side on a light box or light table in the office of an art director. In other

words, color is most critical when slides will be used for reproduction and more attention must be paid to on-camera filtration. Slides intended for projection in a slide show may have greater variations in overall color cast, although in professional presentations, a real effort should be made to keep color quality as consistent as possible.

Assuming that proper attention has been paid to the photographic problems, the most significant element missing from the presentation of slides will be the dimension of sound. For maximum impact, sound-slide shows can be created using a Tiffen Show/Corder, which operates with all the most popular remote-control projectors. This unit allows you to record narration, sound effects, music, and put a signal on the tape that will silently operate the slide projector in perfect synchronization with the sound. Sound-slide shows are ideal for product demonstrations, lectures, sales meetings, and other special applications.

8-2a. The Tiffen Show/Corder makes it possible to easily synchronize sound to slide presentations.

Glossary

ABBERATION—The failure of rays of light, coming from one point through a lens or reflecting from a mirror, to converge to one focus. A condition in an optical system where image-points are imperfect or are improperly located.

ACHROMATIC—Without color. Corrected for equal color reception.

ANASTIGMATIC—Free of astigmatism.

ANGSTROM—A unit of measurement of wave-length, equal to 10^8 cm. or 0.00000001 cm.

APERTURE STOP—That opening in an optical system or instrument which controls the size of the admitted bundle of light.

DEFINITION—In optics, the quality of an image with respect to the rendition of fine detail.

DIAPHRAGM—A thin disk with central hole, placed in an optical system. The term may be used to describe any part which has the effect of a limited opening to light.

DIOPTER—A unit of measurement of refracting power. It is equal to the reciprocal of the focal length in meters.

DISTORTION—That Aberration of an image resulting in the incorrect geometrical representation of the object. Extra-axial image-points are either too near to, or too far from, the center.

FILTER—A sheet of glass or other material of limited transparency (either neutral or colored) used to control the quantity or quality of light permitted to enter the final image.

FOCAL LENGTH—The distance from a lens to the point where it will form an image of an infinitely distant object.

FOCAL PLANE—The plane in which a real image is formed.

FOCUS—A point where light rays are converged by a lens or mirror. To bring light rays together at a point. To adjust an instrument for clear vision.

INFINITY—The extreme point of distance, limitless distance. A focus position at which parallel rays of light accepted by the objective system of a telescope form a real image coincident with the reticle plane.

LENS—The optical medium contained between two refracting surfaces. More loosely, a piece of glass or other optical material comprising two surfaces, whose purpose is to converge or diverge light. A combination of lenses in a single mount.

LIGHT, INFRARED—Light whose wavelength is just beyond the receptive power of the human eye. Light of wavelength 8000—200,000 A.

LIGHT, MONOCHROMATIC—A source which gives off a single color light, all the rays of which are of approximately the same wavelength.

LIGHT, ULTRAVIOLET—Light of wavelength slightly shorter than visible. Light of wavelength of 200-400 A.

MAGNIFICATION—Change in real or apparent size of an image with respect to its object.

MAGNIFYING POWER—The ratio between the angle subtended by the image at the eye to the angle subtended by the object if viewed directly by the eye.

NEWTON'S RINGS—Fringe patterns seen when two optical surfaces are placed together. Interference fringes.

OPAQUE—Does not transmit light.

POLARIZATION—The production of light which is vibrating in a particular plane.

RESOLUTION—The ability of a lens or an optical system to render distinguishable image detail of two adjacent object-points.

SPECTROMETER—An instrument for making measurements through the use of specified wavelengths of light.

SPECTRUM—The band of colored light or any part of it produced when the light from a given source is distributed by wavelength along a continuous band.

VIGNETTING EFFECT—The effect produced when the edges of the field of view are insufficiently illuminated with respect to the central portion. An effect produced by photographers, where there is a gradual fading off of the image into the background.

Index

Adapter rings, 84
Aerial photography, 74
Architectural photography 30, 74—75
Art, 75
Artifacts, 75

Beaches, 75
Black light, 73
Blue filters, 30—32, 70
Blue flash, 80
Blurred motion, 50—51

Clear filters, 20, 69
Clear flash, 36, 80
Close-up lenses, 59—60, 61—68
 diopters of, 61, 66—68
 focal length, 66
 focusing with, 65—66
 fractional, 61
 in combination, 64
 maximum sharpness, 64
 portrait, 61
 with zoom lens, 61—63
Close-up photography, 61—68
 flowers, 68
 insects, 68
 portraits, 68
 small objects, 68
Clouds, 75—76
Color
 alteration of, 70
 cooling of, 36
 darkening of, 20
 enhancement of, 70
 faithful rendition of, 33—34
 film variables, 90—91
 lightening of, 20
 low contrast, 52
 processing variations, 92
 warming of, 36
Color balance, 33—34
Color casts, 76
Color compensating filters, 44, 70
Color separation, 30, 32, 86
Color temperature, 33—34, 39
 Kelvin units to Mireds, 43
 Mireds, 39
Color temperature meter, 38

Combining filters, 38, 39—43, 46—48, 52, 90
Contrast control, 86, 87. *See also* Contrast filters; Low contrast filters
Contrast filters, 10, 20—32
 numbers of, 24
 overexposure with, 24
 underexposure with, 24
 use of, 20—24
Conversion filters, 10, 35—36
Copying, 30, 32, 76—80
Correction filters, 10, 15—20

Daylight
 correction for, black-and-white, 15—17
Decamired filters, 10, 39—43, 70
 combinations of, 39—41
Diffusion filters, 51—52, 69
Diopters, 61, 66—68

Electronic flash, 80
Exposure, 11—12, 87—90. *See also* Neutral density filters.
 multiple, 70—71

Film
 black-and-white, 15
 color, 33—34, 90
 color print, 34, 92
 correct exposure of, 10
 daylight type, 33, 35
 infrared, 30, 71—73
 orthochromatic, 24
 response of, 10
 tungsten type, 34, 36
 Type A, 34, 36
 Type B, 34
 Type G, 34
Filter factors
 determination of, 89—90
Filters
 cleaning of, 14
 combination, 46—48
 effects of, 9—10
 estimating effects, 86—87
 for science, 91
 function of, 7

Filters (*cont.*)
 handling of, 14
 nomenclature, 10
 quality, 12
 sizes, 13
 spectral transmission characteristics, 86—87
Flash. *See* Electronic flash; Blue flash; Clear flash.
Flowers, 68
Fluorescent light filters, 43—44
 FLB, 44
 FLD, 44
Fog, 52—53
 accentuation of, 30
Fog-effect filters, 52—53
Foliage, 30, 32

Grass, 24
Green filters, 17, 32

Haze, 24—26, 30
 penetration of, 26, 30, 34, 35
Haze filters, 17, 20, 34—35

Infrared photography, 71—73
Insects, 68
Interiors, 80

Landscapes, 30, 32, 80—83
Lens caps, 84
Lens shades, 84, 85
Light-balancing filters, 10, 36—39, 70
 exposure factors, 38
 used in combination, 38
Light box, 36
Light, colors of, 7
Light, invisible, 71—73
Light, polarization of, 45
Low-contrast filters, 52

Mired system, 39
Motion picture cameras
 amateur, 34
 Single-8, 36
 Super-8, 36

Neutral density filters, 48—51
 applications of, 48—51
 exposure guide for, 48

Neutral density filters, (*cont.*)
 focusing with, 48, 50
 use of, 48
 with diffusion filters, 52

Orange filters, 24—26

Panning, 51
Photar filters, 91
Photofinishing, 34, 92
Plastic windows, 44
Polarizing filters, 45—48
 combining with other filters, 46—48
 use of, 46
Portrait lens, 61
Portraits, 51, 68, 83
Primary color filters, 30, 32, 70—71, 86
Professional filter holder, 85

Reciprocity failure, 44
Red filters, 26—30
 for infrared, 71, 73

Retaining rings, 84
Romantic effects, 51—53, 56—58

Round-square holder, 85

Selective focusing, 50
Series sizes, 84—85
Show/Corder, 92
Sky-control filters, 53—56
Sky darkening, 24, 30, 46, 53—56
Skylight filters, 34—35
Slide presentations, 92
Slide projector, 36, 92
Slide viewer, 36
Snow scenes, 24
Soft focus, 51
Special-effect filters, 10, 51—60
 diffusion, 51—52
 fog effect, 52—53
 low contrast, 52
 sky control, 53—56
 split-field lenses, 59
 star effect, 56—59
Special-purpose filters, 10
 neutral density filters, 48—51
 polarizers, 45—48
Split-field lenses, 59
Sports, 83
Star-effect filters, 56—59
Step-down rings, 84—85

Telephoto lenses, 26, 61
Tiffen Roto adapter ring, 69
Tungsten light
 correction for, black-and-white, 17
 household lamps, 35
 photoflood, 34, 35
 studioflood, 34, 35

Ultraviolet (UV) filters, 17, 20, 34—35
Ultraviolet photography, 73
Underexposure
 multiple, 70
Underwater photography, 44, 83

Viewing conditions, 36, 90, 92
Vistadomes, 44

Water, photography of, 24
Wood Effect, 30
Wood grain, 83

Yellow-filters, 15—17, 24—26
 effects of, 24—26
 for infrared, 71, 73

4504